SWEETGRASS
BASKETS
and the
GULLAH TRADITION

On the Cover: A sweetgrass basket maker prepares to sell her art on Rutledge Avenue in Charleston during the early 20th century.

SWEETGRASS BASKETS

and the

GULLAH TRADITION

Joyce V. Coakley

ARCADIA
PUBLISHING

Published by Arcadia Publishing
Charleston, South Carolina

Printed in the United States of America

Library of Congress Catalog Card Number: 2005930507

For all general information contact Arcadia Publishing at:
Telephone 843-853-2070
Fax 843-853-0044
E-mail sales@arcadiapublishing.com
For customer service and orders:
Toll-Free 1-888-313-2665

Visit us on the Internet at www.arcadiapublishing.com

*This volume is dedicated to my supportive family and friends
who helped me to collect oral histories for the past 30 years.*

—JVC

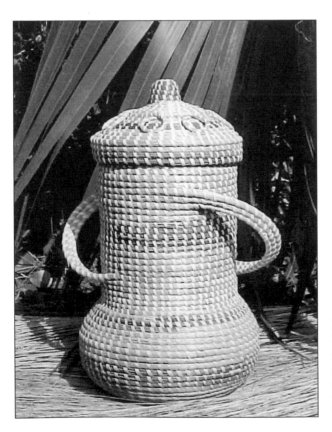

PERFECT UNION. Sweetgrass baskets are crafted in many different styles and sizes. This collector's piece is made of sweetgrass and accentuated with bulrush and pine needles. The top is detachable.

CONTENTS

ACKNOWLEDGMENTS

I am eternally grateful to Mama, Rickeeta, and Rosa for tolerance, support, and encouragement to persevere in this lifelong project; to Sis, Henry, James, Bill, Richard, and Little Charles Henry; and to friends, relatives, and acquaintances who allowed me to interview them over the past 30 years.

My sincere appreciation goes to Lavinia Nelson, Mae Bell and Ike Coakley, Alfred Jefferson, Alice Scott, Henry Dixon, Rebecca Jefferson, Martha Mazyck Green, and Emma Smalls.

I tender my honor and respect to those no longer among the living but who allowed me to ask questions and record them while they were with us: Daddy, Grandmother Dolly, Annie Rose, Uncle Ike, Uncle William, Uncle James and Annie Love, Papa, Annie Missy, all of the pioneer flower ladies of Charleston and especially all the grandparents from the neighborhood who loved, disciplined, and babysat when we were growing up.

My extra special thanks goes to Harland Greene, Dorothy S. Wright, and Jack McCray; Sherman Pyatt and the Avery Research Center; Sharon Bennett and Rebecca McClure of the Charleston Museum; the *Moultrie News*; the *Post and Courier*; Tommy Townsend and the Charleston County School District; Amy Quesenbury and the Charleston County Library; Terry Pound and SCETV; and Adam Latham and Arcadia Publishing.

My applause goes to Damon Fordham and Althea Coakley, and especially to Alfreda German, Wilhelmina Coakley Washington, and Francis Saunders for helping collect pictures from the community.

My gratitude goes to the Buist School faculty of the 1970s; to Emily LaPrice, Emily Ladson, Sarah Gathers (theater), Beatrice Rouse, Grace Chaplin, and Carrie Grady—who taught me in elementary schools—Laing and Moultrie Schools; Charleston Southern University; the Citadel; and the University of South Carolina.

Among coworkers and my support team, I thank Anthony Roper, Leroy Lewis, Dorothy S. Wright, Shonda Johnson, Tom Kascak, Kendal Haynes, Sharon Jefferson, Theresa Jefferson, George LeSueur, and the College of Charleston Help Desk.

My admiration goes to Phoebe McPherson, Smithsonian Institute; Mike Allen, National Park Service; John Rivers, Richard Habersham, Mary and Barney McConnell, and Audra Roper, Quad A Graphics; and James McDuff, IMAGE Photography.

My ongoing devotion goes to my three church families, Goodwill AME Church, where I received catechism; The Garden of Prayer Pentecostal Church; and God's Way Healing and Worship Center.

My heartfelt appreciation goes to Will Scott and Peter Rutkoff who recommended my research to Arcadia Publishing.

And to you my beloved neighbors, relatives, and friends who allowed me to use the invaluable pictures of your loved ones, I am eternally indebted with the gift of love.

Above all, praises, honor, and glory go to the King of Kings and Lord of Lords.

Unless otherwise noted, all photographs are from the author's collection.

INTRODUCTION

Sweetgrass, palmetto, pine needles, and bulrush, along with talent and a true labor of love, create the unique baskets made in Charleston, South Carolina. These handcrafted masterpieces provide the link between African Americans and our West African homeland.

I was privileged to be born in the Christ Church Parish District of Charleston, South Carolina, where my ancestors lived since the 18th century. During the plantation era, they harvested rice, cotton, and other vegetables and crafted many of the historical buildings in the South Carolina Lowcountry. When I was growing up, my grandparents and other older relatives told me many intriguing stories of life on the plantations. From childhood, the ghost stories, medical practices, recipes, Gullah language, religious practices, and games that were prevalent in our community fascinated me. I always asked why things were done in a way that was so different from what I saw on television or read in books. These differences were not so apparent to me until I entered elementary school.

My father was a skilled basket maker who was taught the art by his mother. His parents were always self-employed and relied on the river and the soil for food and income. They used wild herbs for medicine and sold seafood, vegetables, and flowers in the Charleston City Market. My grandmother made many elixirs for various ailments and administered them to us whenever we became ill.

I was also privileged to spend my preschool years at the basket stand of an older cousin by the name of Rebecca Bailem Jefferson. We spent our days crafting sweetgrass baskets and talking about her childhood in the early 20th century. She was able to tell me "slavery time" stories told to her by her parents and grandparents. My mind became a repository of these facts. Each day brought forth a fascinating adventure in the lives of my ancestors. By the time I was six years old, I was able to tell many of the stories verbatim as though I lived them.

After graduating from college, I spent the next 30 years conducting research and recording oral histories from the older people in my community. I continue to be amazed by the beliefs, traditions, and skills of the older generation. Just when I think that I have learned it all, I will record something uniquely different.

Sweetgrass Baskets and the Gullah Tradition is written to provide historical, social, and religious insight into the lives of the basket makers who have preserved the ancient African art form in America for the past 300 years. Writing this book has given me the opportunity to share with the world the culture that I love so very dearly. Charleston is truly the repository of African and American history. For those who may never get the chance to visit historic Charleston, this book will allow you to meet the people and enjoy the art and landscape that help to make it the delightful community that it is. Though I have attempted to share as much as this volume will allow, there are yet many things to see and experience.

Here is the legacy. . . .

CONTRIBUTING ARTISTS

These Mount Pleasant artisans are direct descendants of the Africans who were able to preserve the ancient art of sweetgrass basket making in America. They have inherited the unique skill and technique from their ancestors and have designed and crafted the sweetgrass baskets featured in this project.

Harriett Barnwell*
Wilhelmina Batterson
Dorothy Brown
Joyce Brown
Romelle Brown
Althea Coakley White
Edith Coakley
Elizabeth Coakley*
Mae Bell Coakley
Herline Coakley*
Rosa Coakley
Rosalee Coaxum
Mazie Coaxum*
Adline Dingle
Annabell Ellis*
Betty Fields
Elijah Ford
Florence Ford*
Henry Foreman
Irene Foreman*
Mary Jane Foreman
Camilla German*
Leroy Graddick
Rosa Graddick*
Helen Huger
Linda G. Huger

Willamae Jackson
Anna Lee Lawson
Alethia Manigault
Kathleen Nelson Manigault
Leroy Dangger Manigault
Annabell Mazyck*
Elizabeth Mazyck*
Janie Mazyck
Maggie Mazyck
Sarah German McQueen
Lavinia Nelson
Mary Lee Passmore
Dorothy Reid
Marie Rouse
Rosalee Simmons
Hagar Smalls
Sue Smalls
Elizabeth Turner*
Alma Washington
Henrietta Washington*
Blanche Watts
Geraldine Williams
Ida Wilson*

*—Deceased

One

SWEETGRASS BASKETS
Ancient African Art

The unique art of sweetgrass basket making was brought to the South Carolina Lowcountry in the late 17th century by enslaved West Africans who found palmetto leaves and grasses similar to those used in their native Africa. These skilled artisans were also astrologers, farmers who influenced rice production, blacksmiths, carpenters, and brick masons who built many of the historic buildings of Charleston.

Oral histories give an account of slaves making baskets to winnow rice and store dry goods. Following the Civil War, as freed families attempted to establish a household, utensils were extremely limited. The baskets were made in large quantities to store dried grain, vegetables, salted fish, corn, and wild herbs saved for medical purposes. Since that time, the art has become a collector's item to many across the world. Many creative styles have evolved over the centuries, but the technique and natural materials remain the same.

Farming was the main source of income for most people in the community, and other job opportunities were limited in the early 1900s. Many families living in Mount Pleasant relied on sweetgrass and the baskets they made from it to provide income. With the birth of tourism in the South, there was suddenly a demand for souvenirs expressing the unique nature of the region, and sweetgrass baskets were ideal. In many ways, the time spent sewing baskets became a valuable tool in the preservation of Lowcountry African American history. Not only was a traditional craft passed on, but the making of baskets afforded the opportunity for older relatives to share lore, family traditions, and historical events as recorded by their enslaved relatives. As many as three generations could be seen working for five to six hours daily on a porch or under a shade tree in summer and around a fireplace or wood-burning stove in winter. For those with family stands, a mother was accompanied by a daughter daily during the summer and sometimes on Saturdays during the school season. Elders talked and children listened as fingers worked the grass.

GLOSSARY OF COMMON SWEETGRASS TERMS

GRASS—*muhlenberia filipes*, perennial seagrass, used to make sweetgrass baskets; grows along the Carolina coast. It is called sweetgrass because of the aroma when freshly harvested. The growing season is from early spring to late summer.

MADA (long A sound)—strips of the leaf of a palmetto tree used to sew sweetgrass baskets.

BULRUSH—*Juncos roemerianus*, perennial sedge that grows in wetlands. It is used to add color and firmness to the sweetgrass baskets. Bullrush is nicknamed russia or rushel in the Lowcountry.

NAILBONE—an instrument used for piercing when making a sweetgrass basket. Enslaved Africans used the filed rib bone of a cow or pig as their only construction tool until the late 19th century. When they were allowed the use of metal, a filed spoon or fork replaced the rib bone.

WRAP (also wrop or wind)—to secure sewing material by making a half stitch.

FEED—to add sweetgrass, pine needle, or bulrush to basket while in the construction process.

BASKET HOUSE—a small wooden building used to store baskets overnight, primarily used before 1960.

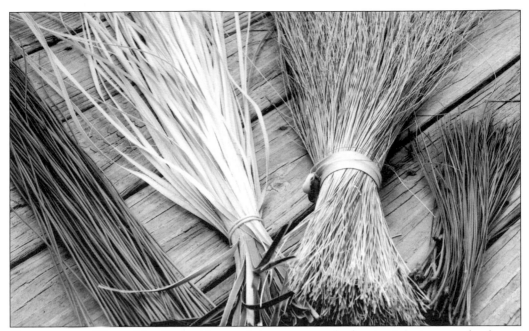

GONE IN THE WIND. The first evidence of the sweetgrass basket in America was the fanner used to thrash rice. Thrashing was a process of tossing the rice upward so that the wind would separate the hull from the grain. The need to make other household storage containers and the availability of natural resources contributed to the perpetuation of the art form and creation of other styles.

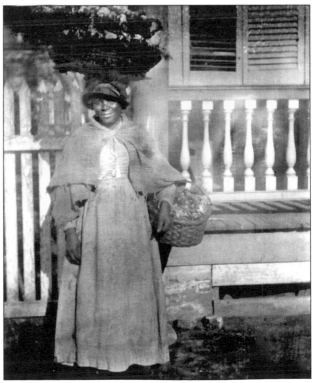

TO HAVE AND TO HOLD.
Enslaved West Africans constructed sweetgrass baskets to store grain, dried vegetables, nuts, and other household products. As street vending became popular, basket makers took fruits, vegetables, and flowers to sell in nearby Charleston. The typical fanner baskets were used to transport these products. This unidentified woman displays the skill of carrying flowers and vegetables in a basket on her head and one on her arm. (Courtesy of Charleston Museum.)

SLAVERY V. STATES RIGHTS. On April 12, 1861, the first shot of the Civil War was fired on Fort Sumter by Confederate troops. The causes of that war were determined by history to be slavery and the individual rights of states. Both issues divided the nation. The war significantly impacted the Africans living on South Carolina plantations. In 1863, President Lincoln signed the Emancipation Proclamation, freeing the enslaved Africans of Mount Pleasant and the rest of the South. (Courtesy of Charleston Museum.)

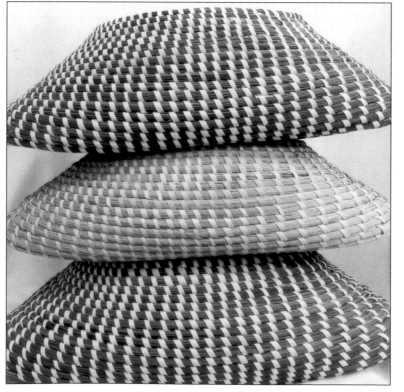

FREE TO WORK. After 1863, newly freed Africans had to use the skills taught by their ancestors to build homes, establish households, and earn income. Many of those living on Boone Hall Plantation remained in their brick cabins and worked the farm. Sweetgrass baskets were made to store dried grain, okra, salted fish, corn, and wild herbs. Northern tourists visited the plantation and brought back the baskets that they saw throughout the estate. The basket shown here is "Dream of Rivers."

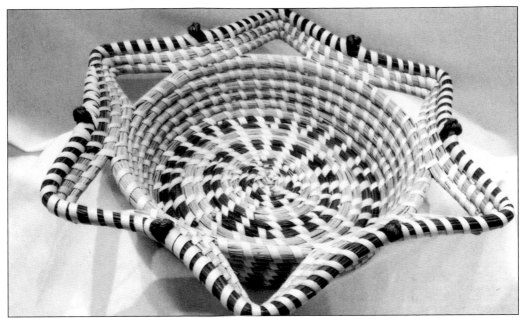

WE WAKE THE SUN. By the early 20th century, sweetgrass baskets were being shipped to New York stores and galleries for sale. Collectors purchased decorative baskets to add to their memorabilia. Ike Coakley recalls that in 1918, at the age of seven, he and his sister Love left home at 3:00 a.m. and walked seven miles to Shem Creek to take the ferry to Charleston. They delivered sweetgrass baskets to a broker on East Bay Street who shipped them to New York. This basket is "Blazing Star."

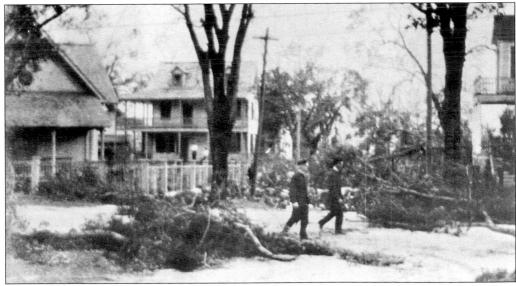

THE STORM THAT SAVED US. The Carolina coast has been nicknamed "Hurricane Alley." The Storm of 1911 was one of the most devastating. Ike Coakley, born that year, recalls his mother telling him that this was the year the sweetgrass baskets shifted from domestic tool to a commercial enterprise. The storm destroyed the harvest, and families were desperate for income. The community combined efforts and took sweetgrass baskets to Charleston to sell for the next meal. A Charleston street is shown here after the 1911 storm. (Courtesy of Charleston Museum.)

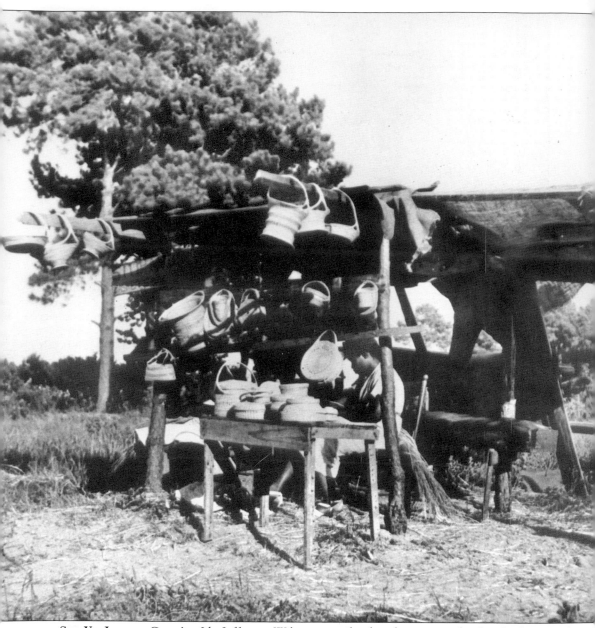

SEE YA LATER, CAPT'N. Ida Jefferson Wilson is credited with erecting the first basket stand on Highway 17, shortly after the construction of the highway in the early 1930s. She was living in one of the former slaver quarters at Boone Hall. While working in the strawberry field, she became engaged in a fierce argument with the overseer, who told her to leave the property. She and her husband, Jack, sought other means of earning income. "Dem beel* out da on dat road, some of dem might stop and buy a basket," said Jack. The next day, she hung several pieces from a ladder-back chair clad with a white sheet and sold a fruit basket. (*Dem beel—those cars.) (Courtesy of Charleston Museum.)

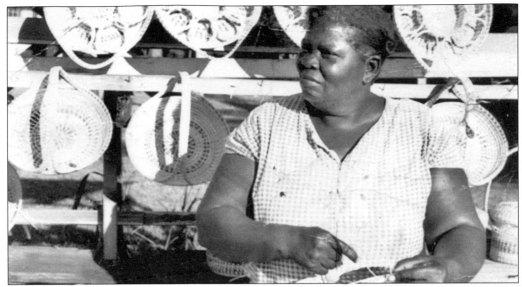

Thinking Outside the 1940s Box. Ellen "Nuhka" Barnwell and her husband, James, lived on Highway 17. They were one of the first African American families to have electricity. Electricity created an opportunity for creative marketing of their sweetgrass business. They decided not to compete with the daytime vendors but to sell on Saturdays from late afternoon until nearly midnight. They illuminated the stand with numerous 25-watt bulbs, creating a scene that welcomed travelers on the dark 50-mile stretch from Georgetown to Mount Pleasant. (Courtesy of private family collection.)

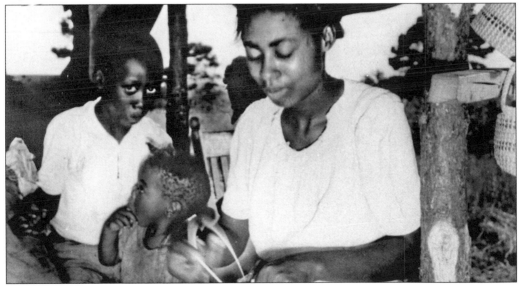

Experience Is the Teacher. Most children learned the art by observing their elders, as no formal lessons were taught in the early years. Discarded supplies were gathered from the floor and young hands seized the opportunity to replicate pieces being made by adult artisans. Basic instructions were given on how to feed the basket, build up, and add a handle and top. Young children made bottoms for their parents, who created larger, more decorative styles. Age, experience, and demand encouraged the construction of more complicated pieces. Pictured here are Viola Jefferson (right) and her siblings. (Courtesy of Charleston Museum.)

4

9·4│7·0·2 EL

UNITED STATES OF AMERICA
OFFICE OF PRICE ADMINISTRATION

WAR RATION BOOK FOUR

Issued to _Emma Jackson_

(Print first, middle, and last names)

Complete address _____

READ BEFORE SIGNING

In accepting this book, I recognize that it remains the property of the United States Government. I will use it only in the manner and for the purposes authorized by the Office of Price Administration.

Void if Altered

BLESSED SHALL BE YOUR BASKETS. The 1940s were a difficult era; ration books were required to purchase common household goods. Sam Coakley—local preacher, church class leader, singer, boat builder, farmer, community activist, and basket broker—organized Depression-era sweetgrass basket makers to sell to businessmen in Charleston. He encouraged the artists to create styles that would get them a better price. His daughter, Mary Jane, did the first sweetgrass basket show at the White House. Her basket was on display at the Smithsonian Institute. (Courtesy of private family collection.)

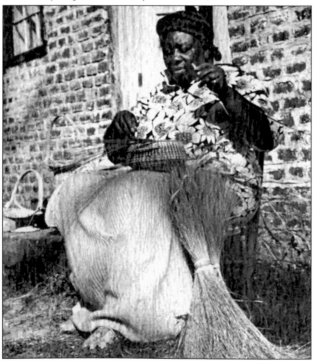

FROM THE HIGHWAY TO THE SKYWAY. The sweetgrass basket industry expanded far beyond the Charleston community in the 1960s, when Edna Rouse (shown here outside of a cabin at Boone Hall Plantation, where she spent her early childhood) and Wilhelmina Seabrook participated in a craft show in Canada, having previously traveled to North Carolina and other neighboring states. The pair won numerous blue ribbons and brought international attention to the art. Later Elizabeth Seabrook Coakley had several designs featured at the Smithsonian Institute in Washington, D.C. As a preservation effort, Mary Jane Bennett taught the first basket sewing classes in the community. (Courtesy of South Carolina Education Television Commission.)

"ON MY HONOR, I PROMISE TO UPHOLD THE INTEGRITY OF MY FOREFATHERS."
Founded by seven members of the Christ Church Parish community in 1987, using oral history, written documents and artifacts, the Sweetgrass Cultural Arts Preservation Society was established to protect and preserve the unique historic and cultural integrity of sweetgrass basketry and all other art forms and customs brought to the South Carolina Lowcountry by enslaved West Africans. Rosa M. Coakley, age four, is being taught the creed and art form by her grandmother Rosa G. Coakley. The basket is "The Covering."

ONE HUNDRED YEARS OF ARTISTIC CRAFTSMANSHIP. Janie Campbell Mazyck, born August 15, 1905, grew up in the Hamlin Beach community and was taught the art by her mother, Mauriah Campbell, at age five. She and Adline McCall Dingle are Mount Pleasant's oldest active sweetgrass basket makers. (Courtesy of private family collection.)

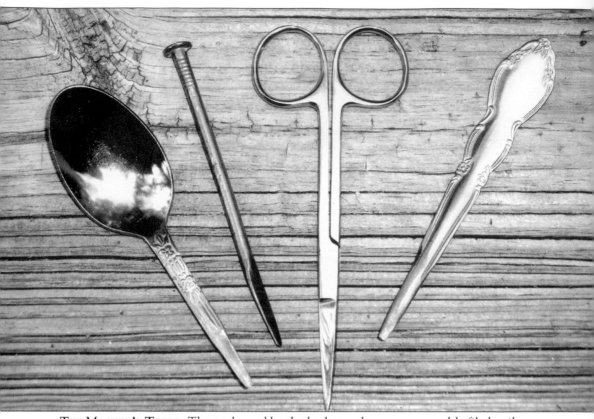

THE MASTER'S TOOLS. The tools used by the basket makers are a smoothly filed nail, spoon, or fork, and a pair of scissors for cutting.

Two

GULLAH

In the absence of formal teaching, the Africans who were brought to the Carolina coast attempted to communicate with Europeans and other Africans in a language that was completely foreign to them. Out of this effort came the Gullah language. The term Geechie is often used interchangeably to describe the people and lifestyle of African Americans living from northern Jacksonville, Florida, to Jacksonville, North Carolina; Charleston, South Carolina, is at the heart of this region

The influence of Gullah on the language and life of Charleston is pronounced—so much so that the city could actually be called a bilingual community. Gullah ingredients season Lowcountry foods, just as Gullah words, songs, poems, terms, and phrases are still heard in homes, schools, churches, on the streets, and in public places.

In the 1930s, the Gullah language reached a national audience when it was heard in DuBose Heyward and George and Ira Gershwin's *Porgy and Bess,* an opera that took to the stages of the world the story of a street vendor of Charleston. The main characters are a physically disabled man named Porgy and his beloved Bess. Since that time, Gullah has been represented on television and in movies and written of in books and magazines; even the Bible has been translated into it. Although disappearing on the streets of Charleston, the language and folk ways have been richly retained in the rural Lowcountry.

Gullah is the spice of Lowcountry life.

Gullah Names and Titles

BUH (OR BAH)—often added in the front of a man's name to denote honor and kinship: James Moultrie was called Bah Moot.

DAH—added in front of a woman's name to denote the same kinship and honor. It could be used in place of grandmother or aunt. A midwife was also called a dah. Dah Tina—Christina Rouse—was the midwife in the 10 Mile community for more than 70 years.

The Hamlin and Phillip communities have maintained use of the Gullah language and much of the African traditions. The language can still be heard among both the elderly and young children. Many children in the community were privileged to be given nicknames that were apparently of African origin: Muhbee, Mawnee, Bramboo, Booloo, Buhsome, Buhgee, Tingaboo, Anew, and Yah (short A sound in both).

Gullah Verbs

Verbs in Gullah are conjugated with the words been and done.

| He been don gon. | *He's been gone for a long time.* |

DEAD

'E dead.	*He/she is dead. He/she has died.*
'E been dead.	*He/she died sometime ago.*
'E been don dead.	*He/she died a very long time ago.*

EAT

I duh eat.	*I am eating.*
I don eat.	*I have eaten.*
I been don eat.	*I ate a while ago.*

KNOW

I know dat.	*I know that.*
I had know dat.	*I knew that previously.*
I been had don know dat.	*I knew that for a very long time.*

GULLAH

Gullah is a language for the people, from the people, and to the people. In the Gullah language, simple phrases are used to describe or provide definition to more complex ideas:

ADVICE TO SOMEONE CONTEMPLATING MARRIAGE:
Come see ein like come stay.

Visiting her is not like living with her.

DESCRIPTIVE PHRASE:
Come yuh or been yuh?

Are you a tourist or a resident?

GOSSIP:
Dog bring bone, e cah bone.

A person who brings news will carry news.

NOUN PHRASE:
Deep-eye chillen.

Ungrateful children who want much. Someone who is greedy.

'E eye long.

The person is greedy.

Common Gullah Phrases

Uh mean fuh do so.	*I meant to do it.*
See um da.	*See it there.*
Bring em yuh.	*Bring it here.*
I ein know.	*I don't know.*
I ein been know.	*I (really) don't know.*
Wha fuh?	*What for?*
I got da misery ein my head.	*The pain is in my head.*
Muh head da hut me.	*My head is hurting me.*
Trow em ober da.	*Throw it over there.*
Who pa you?	*Who is your father?*
She do em fo she.	*She did it for her.*
She do em fo e left.	*She did it before she left.*
Oh, you ein been know dat?	*Oh, you didn't know that?*
E been don dead.	*He has been dead for sometime.*
Who dat ein da?	*Who's that in there?*
Yiddie so.	*I heard it.*
Yuh so.	*I heard it.*
Wha hunnah da do ein da?	*What are you all doing in there?*
Wha e been yat?	*Where was he/she?*
How much e fa?	*How much is it?*
Wha time da gwine ein da crick?	*What time are we going in the creek?*
Da pot da bile.	*The pot is boiling.*
Him bex.	*He is vexed (angry).*
Who dem flowiz fa?	*Who are the flowers for?*
Hush da nize.	*Hush the noise.*
How'l ole e is?	*How old is he?*
Hunnah da lie!	*You all are lying.*
Him eye long.	*He's greedy.*
You yent.	*You lie.*
Him say him da man.	*He says he's a man.*
Him smell him man.	*He's fresh.*
Him say him fuh married.	*He says he wants to get married.*
Liza tell em fuh do so. (only in use at Boone Hall)	*Her mind told her to do that.*
How ole he is?	*How old is he?*
No olda; no younger. Jus' so.	*The same age as he is now.*

DAH. Dah is the term commonly designated for mother, grandmother, aunt, relative, or caregiver. This unidentified woman was most likely addressed "Dah Mary" or Sue or Alice. (Courtesy of Charleston Museum.)

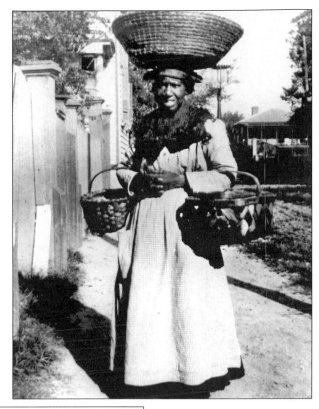

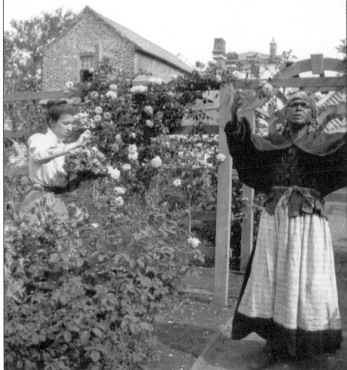

SPIRITUAL SUNG IN GULLAH. Unique to the South Carolina Lowcountry were the praise songs sung at prayer meetings. One popular spiritual is "I'm Not Coming Back Again":

I'ein comin back no mo,
I'ein comin back no mo.
Bid dis world a long fa'well
[farewell] an I'ein comin
back no mo.
Soon'z muh foot strike Zion,
and da lampos' light up on
dah sho'
Bid dis world a long fa'well
An' I'ein comin' back no mo.

The woman on the right raises her hands upward as she sings a praise song.

(Courtesy of Charleston Museum.)

23

THE SEWING BOX. This style was first introduced as a container for women to store needles, threads, and knitting supplies.

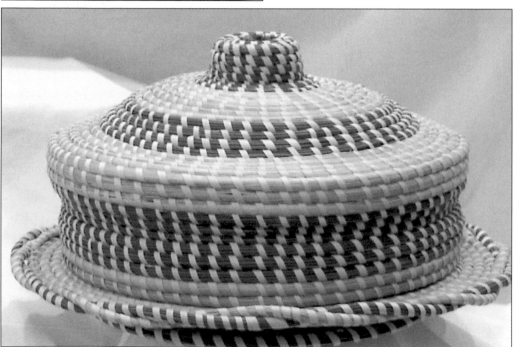

MIDNIGHT TREAT. First introduced in the 1960s, this style is used as a cake plate or as a decorative piece in the dining area.

Three

PLACES . . . CHRIST CHURCH
The Cultural Repository

Christ Church Parish, home of America's sweetgrass basket makers, was created out of the Church Act of November 30, 1706, which divided the province of South Carolina into 10 parishes to serve the political and religious needs of the settlers. Christ Church spanned a seven-mile track of land from the Charleston Harbor to the Wando River. The primary building was a wooden structure burned by the British during the Revolutionary War in 1782 and later burned by the Union army during the Civil War. The community was primarily inhabited by African Americans following the signing of the Emancipation Proclamation, the document that freed the slaves.

Today the area consists mostly of the city of Mount Pleasant, once only linked to the city of Charleston by ferries. Christ Church Parish now, thanks to bridges (first constructed in 1929), is part of the larger Charleston metropolitan area. Despite the growth of suburbs, urban sprawl, shopping centers, highways, and the like, old neighborhoods and communities still exist. Here the descendants of slaves and freedmen live on.

THE BIRTHPLACE OF BEAUTY.
Wilhelmenia Swinton Rouse, a basket maker, farmer, and mother of 10, attended the local one-room school in Mount Pleasant. Abbey Munroe, the first principal of Laing School, wrote in 1867 to friends in Philadelphia: "Mount Pleasant is an exceedingly helpful village, nearly opposite the city of Charleston, on the shore of the bay looking directly upon Fort Sumter, Fort Moultrie, Morris Island and other points of historic interest. It is reached by ferryboat. . . . It is popular as a summer resort for the businessmen of Charleston."

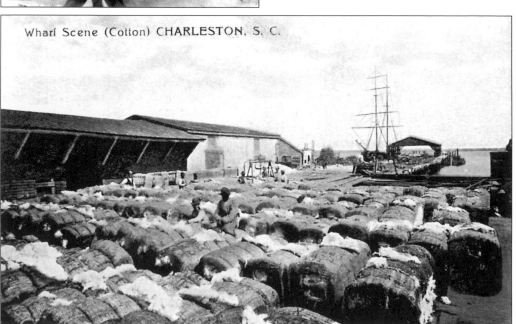

Wharf Scene (Cotton) CHARLESTON, S. C.

CROPS MADE CHARLESTON QUEEN. As cotton, rice, and other crops produced lucrative profits for businessmen on local plantations, Charleston became one of the leading ports for shipping crops to England and other destinations. The Africans made up the labor force that both harvested and shipped cargo from the colony. (Courtesy of Charleston Museum.)

BIRTHPLACE OF DEMOCRACY. Sarah Washington (right) and Evelina Pringle grew up on Laurel Hill Plantation and worked the pecan orchard and farm until the 1920s. The plantation was in the community of Phillip, now called Phillips, named by Dr. John Rutledge. He was a signer of the Constitution, a U.S. Supreme Court justice, a member of the Continental Congress, and a South Carolina governor. Edward Rutledge, his brother, was a signer of the Declaration of Independence. They were grandsons of John Boone, the owner of Boone Hall Plantation. (Courtesy of private family collection.)

SON OF THE CONFEDERACY? Hazzard Rouse, son of a Confederate soldier, lived in the African American community of Phillip, established when freed Africans began purchasing property from the Horlbecks—who owned Boone Hall, Laurel Hill, and Woodlawn Plantations—in 1878. Among the community's founders were Hercules Geddis, gristmill owner; Joseph Rouse, shopkeeper; farmer Sipio Smalls; Junno Tourneau, who owned a boarding house; and Civil War veterans Sammy Scott and Thomas Rouse. The land is still owned by the families of the original owners, who have maintained the crafts taught by their forefathers. (Courtesy of private family collection.)

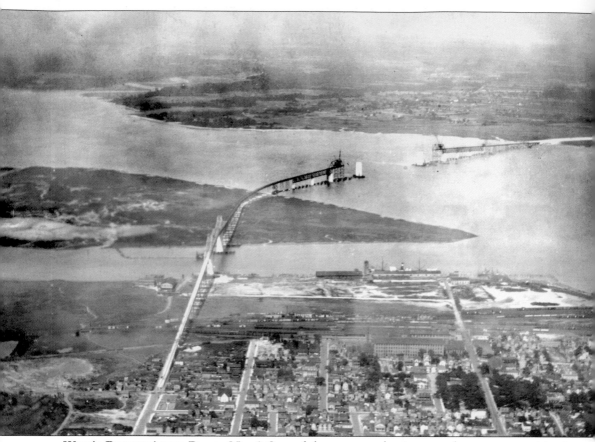

WHO'S RUNNIN' THE PLACE NOW? One of the most productive post-slavery communities in Mount Pleasant was Remley's Point, seen here at the top left of the page. Charleston County records indicate that John Scanlon, a freed African, purchased it in 1868 for $6,100. Once a thriving 600-acre plantation, the property also is the site of Revolutionary War–era fortifications. Historical documentation states: "about 100 poor colored men of Charleston met together and formed themselves into a Charleston Land Company whose mission it was to help the newly emancipated Africans to acquire land. They subscribed for a number of shares at $10 per share, one-dollar payable monthly. The people were allowed to purchase property for $20 per half acre and become stockholders in the company." The Charleston Land Company of Remley's Point remained viable until the Great Depression of the 1930s. It provided for a graveyard and a community park and also had provisions to care for the elderly and sick, necessary due to the number of destitute elderly former slaves. The original plantation produced beans, cotton, corn, peas, rice, sweet potatoes, and white potatoes. The livestock of 150 recorded in an agriculture census included cows, horses, sheep, and pigs. It was probably not as populated as the other Christ Church plantations, since the 1860 census for the Remley's Plantation listed only 14 African slaves and no whites. It was probably controlled by a slave driver or an overseer. This photograph shows the building of the Cooper River Bridge in the 1920s. (Courtesy of Charleston County Public Library.)

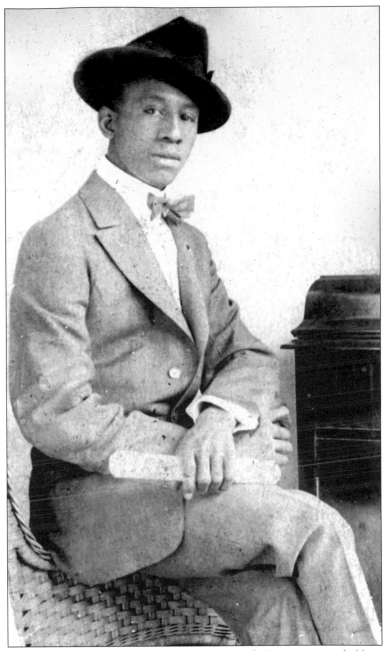

UNDERGROUND FUNERAL HOME. The Johnson Funeral Home was probably one of South Carolina's most famous. The owners, Peter and Margaurite Johnson, were from the community and had a deep concern for the people. When Peter opened the business, he had the awesome responsibility of moving the community from African burial traditions to compliance with the law. There was great resistance, as burial traditions were sacred and considered a part of worship. Peter, his cousin Raleigh Johnson, and friends Ernest J. Brown and William Gold also organized classes at Friendship AME Church to teach the people how to sign their names and, most impressively, taught them the importance of the fight for the right to vote. (Courtesy of private family collection.)

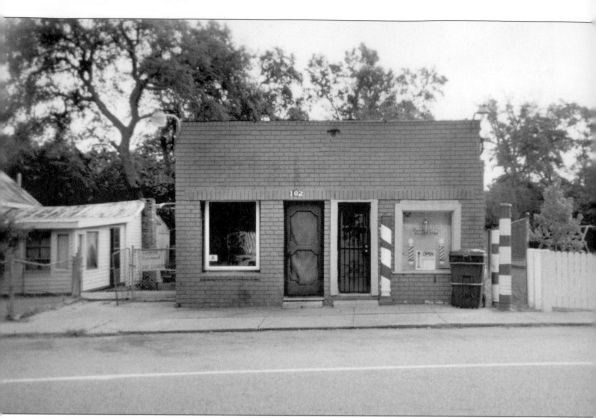

HOT SPOT. H and R Sweetshop, "A Meeting Place for Friendly People," opened its doors on Monday, April 3, 1945. Owners Raleigh and Harriet Johnson wanted a place where children and adults could come to socialize and get something to eat at a reasonable price. During hard times, most ate on an eat-now-pay-later basis. The shop became the primary gathering place after weddings on the weekends and also served savory meals throughout the week: Monday: stewed chicken, Tuesday: okra soup, Wednesday: cabbage, Thursday: lima beans, Friday: red rice, fish, and shrimp. The award-winning ribs, using a secret-recipe barbecue sauce, have been a community delight for the past 60 years. No visit to the Lowcountry is complete without a meal at the H and R Sweetshop at 102 Royal Avenue in the Old Village of Mount Pleasant.

HIGHWAY 17: THE ROAD LESS TRAVELED. Highway 17, once a deserted strip between Charleston and Myrtle Beach, has become the major route for tourists from the North. This opened the door to the roadside stands that now adorn the highway. Shown here are Catherine Coakley (left) and Louisa Gillard. (Courtesy of private family collection.)

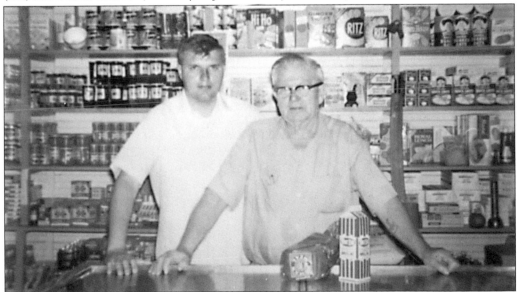

ONE-STOP SHOPPING. The A. B. McConnell store was the hub of communication for African Americans in the basket making community. It served as the local post office and was the grocery/hardware store. Local residents wishing to have their groceries delivered would submit a list early on Saturday morning. The young men working at the store boxed and prepared the items for delivery in the McConnells' pickup truck. The purchase was paid for in cash or placed "on the book" for later payment. Payments were made on payday or on the first of the month. Barney McConnell (left) and Aaron Blakely McConnell are shown here. (Courtesy of private family collection.)

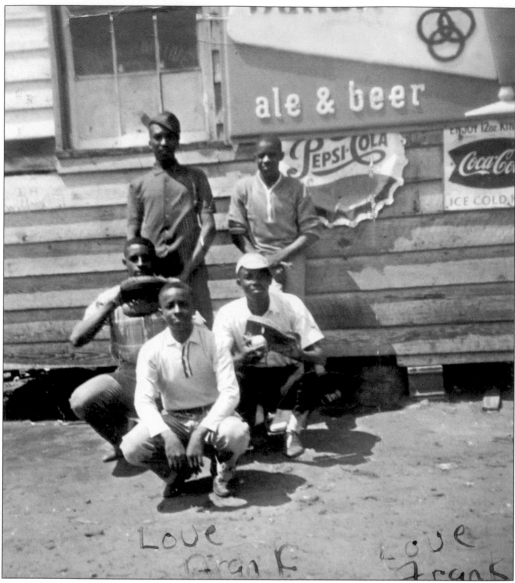

THE GATHERING PLACE. Louis "Boofee" Coakley, Isaiah Manigault, Harold Horlbeck, Clarence Jefferson, and Frank Jefferson pause for a moment of fun at Johnson's Candy Store, the center of activities for the Hamlin Beach community. The store offered many choices: Coke or Pepsi, Mary Janes or Squirrel Nuts, Rock 'n Roll or Honey Bun, potato chips or pork skins, and a variety of other chocolate delights. Most of the candy stores also served as barbershops. They were owned by those who lived in the community, and the building was sometimes attached to the family home or was a small structure in the yard. Beverage companies supplied various metal signs to advertise their products. The store hours were usually from after school until "gray dust." During the summer, the store was open from noon until evening. (Courtesy of private family collection.)

LAST STOP, FINAL DESTINATION, ALL THE SAME. Oceanview Cemetery in the Mount Pleasant Village dates back before the Civil War. African Americans are buried on one side and whites on the other, separated by a path named Victory Lane. Civil Rights activist Edmund Jenkins, for whom Mount Pleasant's only public housing project was named, is buried at the front of the cemetery. Six miles away, in the Hamlin Cemetery, is the grave of Mike, the slave who informed the Hamlin family of an insurrection planned by fellow slaves. His grave is larger than those of Hamlin family members who fought in the Confederate army. Mike's grave faces east, an African burial tradition.

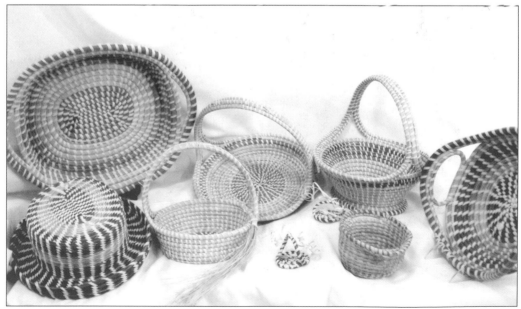

SILENT SYMPHONY. This collector's group features a variety of pieces representing several eras in basket making.

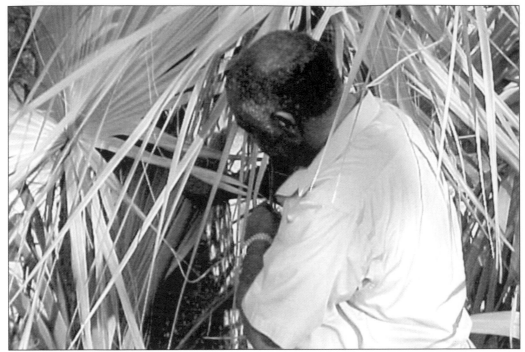

FOR LATER USE. Henry Foreman gathers palmetto leaves to sew many styles of baskets. The leaves are placed in the sun for several days until they turn golden brown. They can be placed in the freezer for use a year later.

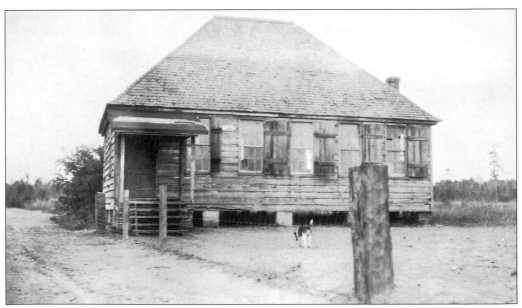

CHURCH AND STATE WORKING TOGETHER. The old Phillips School, established in the late 19th century for children from Laurel Hill Plantation, Parkers Island, and the Phillips community, remained open until the mid-1950s. It also was used for evening prayer meeting on Tuesdays and Thursdays and was called "the classroom." (Courtesy of Charleston County School District.)

Four

HISTORICAL HAPPENINGS

The residents of Mount Pleasant have always seized the opportunity to celebrate. From the visitation of George Washington in the 18th century to the roadside parties of the 20th century, a unique style of social and religious activities have been recorded through oral histories and written documents. Many events were celebrated for more than 200 years; some were historical, and others blended ancient African and Colonial American traditions. Annual excursions were sponsored by churches and social organizations to Atlantic Beach; Savannah, Georgia; Beaufort; and Columbia. The sponsors sold soft drinks, peanuts, and sandwiches, while travelers provided their own snacks, consisting of red rice, fried chicken, fish, Kool-Aid, luncheon meat, bologna, and cornbread.

Excursions became a major fund-raiser for churches and social clubs. For most, these annual trips were the only family vacations. New clothes were purchased, and all generations able to travel climbed on board the bus. Annual photographs were taken with friends. It was a time to socialize and celebrate historical events such as the signing of the Declaration of Independence, Memorial Day, and Labor Day. All excursions were held in late spring and summer.

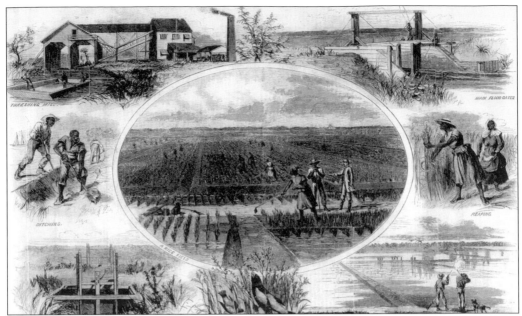

GOOD MAWNIN', MR. GEORGE. In 1791, George Washington visited the property of Charles Pinckney on Long Point Road, one of the largest rice-growing plantations in the Lowcountry. West Africans made up the labor force that built the levees approximately 5 feet high and 12 feet wide, used for production of the rice. The gates in the rice banks allowed workers to drain and flood the tidal marsh, where the crop was grown. (Courtesy of Avery Research Center for African American History and Culture.)

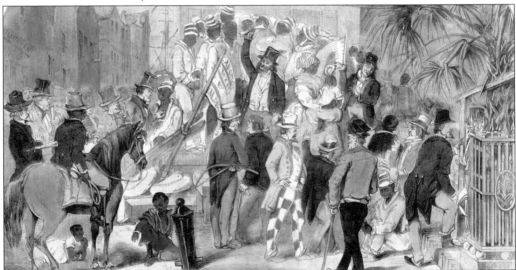

ANNUAL BLOOD DRIVE—NO ONE REFUSED. Traditionally January 1 was a day of slave sales on Southern plantations. Masters allowed for a big feast the night before. It was on this "Watch Night" occasion that the Emancipation Proclamation was first read. The New Year's celebration continued in Mount Pleasant with the singing of "Watchman, Tell Me the Hour of the Night." They served Hoppin' John, a dish made with field peas and rice, greens, and sweet potatoes. This meal is still served in the Lowcountry. This is a slave sale in Charleston in the 1850s. (Courtesy of Avery Research Center for African American History and Culture.)

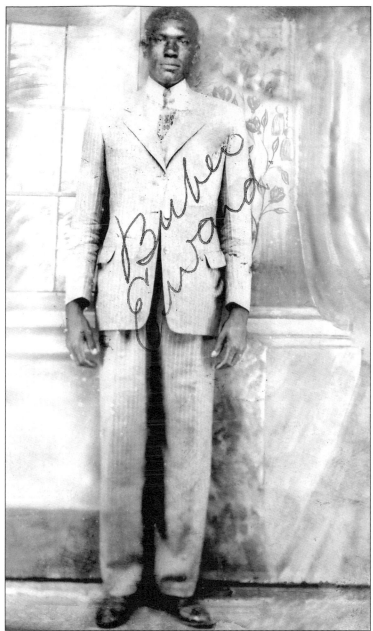

IN HONOR OF AUGUST 28, 1876. Abraham "Buber" Edwards was active in the church and in the Mount Pleasant community. The following excerpt from *The News and Courier* in 1876 describes a gathering Edwards may have attended: "While the Democrats of Charleston were in the midst of their grand demonstration on Friday night, the colored residents of the Town of Mount Pleasant had a meeting in the town hall to discuss the political situation. It was the largest meeting of colored men that has ever been held in the village. A number of white citizens were invited to be present and participate in the discussion, and the invitation was accepted. On the motion of Fred Wilson the meeting was called to order, and Scotland Small, a colored member of the town council, was selected chairman. The meeting was quiet and harmonious and none but the kindest feelings prevailed." (Courtesy of private family collection.)

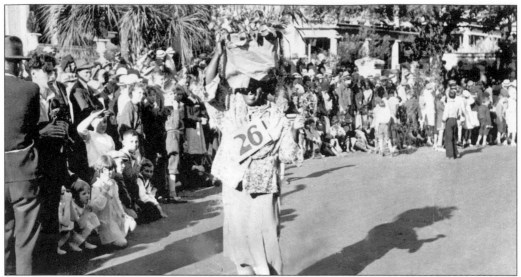

MARCH TO VICTORY. Parades offered the community a periodic opportunity to integrate. Beauty pageants, vegetable displays, and flower arrangements adorned carts—all added to the beauty and diversity of the celebration. Contestants did their very best to woo the judges by dancing and performing antics. Winners were named and monetary prizes were awarded. During the Great Depression, William "June Coke" Coakley and his cow Belle were proud winners of the best-decorated carts award; the award went to other local residents as well. This is a 1930s Azalea Festival in Charleston. (Courtesy of Charleston Museum.)

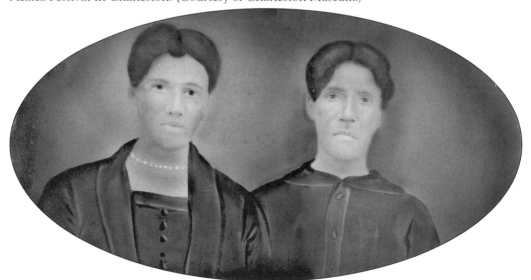

CAKE AND WINE: LOVE FOR A LIFETIME. The first wedding ceremonies after slavery were conducted at the county courthouse in Charleston. Later they were held at the home of the bride in the front yard with the happy couple standing on a white sheet. Circuit preachers performed the ceremonies, usually on a Sunday afternoon in June after the couple had a yearlong engagement. Berries were gathered for homemade wine, the only beverage, served with cake. In the late 19th and early 20th centuries, newlyweds lived with in-laws. Pictured are Irene Butler Foreman (left) and Muriah Butler, who made cakes for such weddings. (Courtesy of private family collection.)

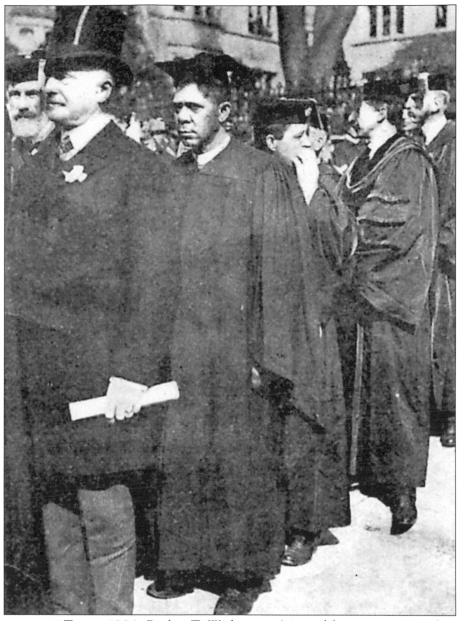

STATE OF THE TOWN, 1904. Booker T. Washington (pictured here receiving an honorary degree in 1904), a slave turned schoolteacher who founded Tuskegee Institute in Alabama, was a friend of the Laing Industrial School in Mount Pleasant. When he visited on March 20, 1909, *The News and Courier* reported: "Booker T. Washington Here. . . . There is one respect in which both races, not only in South Carolina, but in the South generally, suffer at the hands of public opinion of the outside world. The reason for this is that the outside world hears of our difficulties, hears of our crimes, our mobs and lynching, but it hears very little of the normal, healthy progress that the people of both races are making in every day in the year. It sees few of the evidences of the racial friendship and good will which I found to exist in every one of the communities in South Carolina and do the Southern stares which I have visited." (Courtesy of Avery Research Center for African American History and Culture.)

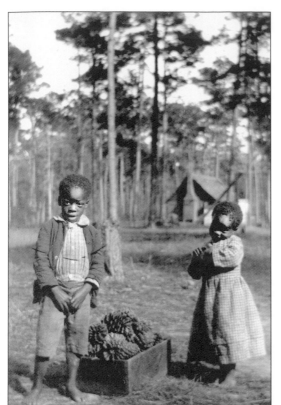

TODAY IS CHILLEN DAY! "I da coutin [courting] da yella gal [mulato], my bubba da coutin 'em too. Now, the only way I kin git da yella gal is to put on my long tail blue," was the Chillen (Children's) Day speech recited by Charles Mazyck *c.* 1920. The community gathered under shade trees or at local meetinghouses, then at churches, to hear children recite speeches prepared by parents. Girls dressed in gingham dresses and boys in a semblance of a suit. (Courtesy of Charleston Museum.)

HOMEMADE FUN. Roadside parties were major events. In the Hamlin community, they were held under the huge oak tree in Manigault Corner. Partygoers in the 1920s gathered to hear Lil' Ike (Coakley) on the guitar and Bossie Manigault on the zoo zap (Jew's harp). The group sang the popular "Show Dem Boys Yuh BB Leg." Meals consisting of field rats and rice in the late 19th century, rabbit and rice in the 1920s, and squirrel and rice in the early 1930s and 1940s were served. (Courtesy of Avery Research Center for African American History and Culture.)

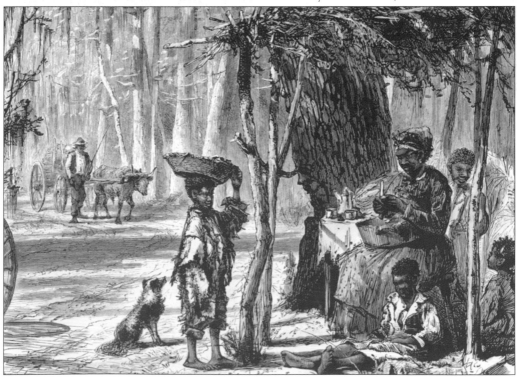

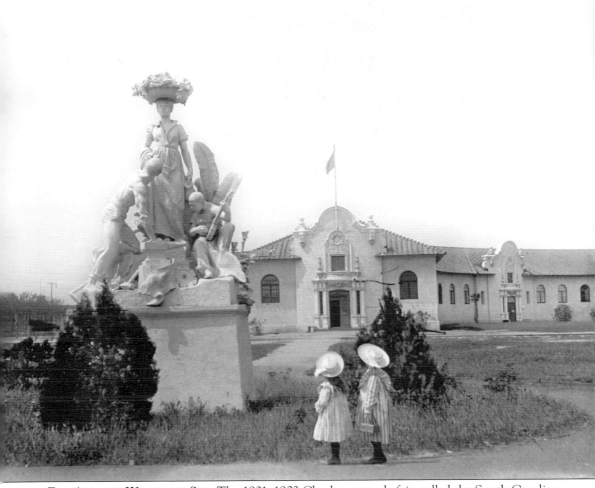

FOR ALL THE WORLD TO SEE. The 1901–1902 Charleston trade fair, called the South Carolina Interstate and West Indian Exposition, was a unique experience for the recently freed African Americans in South Carolina. The Negro Building at the Exposition featured a sculpture done by Charles Lopez. Homemade baskets were a popular art in the South Carolina Lowcountry, and fruit and vegetable vending was one of the primary occupations after freedom. (Courtesy of Charleston Museum.)

EVERYONE NOW KNOWS US. Students from the Laing Industrial School participated in the Exposition attended by Pres. Theodore Roosevelt and his wife. Abbey Munroe wrote in a 1902 letter, "Good and satisfactory work has been performed in the Industrial Department (of Laing) the past year. The first weeks were devoted to preparing work for our exhibit at the Exposition. . . . The pupils entered into it heartily, and the variety of garments from the sewing room, the neatly prepared shoes from the cobbling shop, together with the specimens of handwriting, the examination papers, and pen and pencil drawing from the higher rooms, have won many words of commendation for our pupils and teachers. . . . Though it was the Liberty Bell in the Philadelphia exhibit that drew the attention . . . we found the exhibits in the Negro building especially interesting and well examined by visitors. . . . The Laing School exhibit has received a number of pretty compliments, especially the specimen of handwriting by the pupils." (Courtesy of Charleston Museum.)

MAN ON A MISSION. Willie Green (far left) was a young man with dreams of becoming rich. The construction of Highway 17 and the advent of electricity allowed him to open a two-story nightclub in the Seven Mile area in the 1940s. There were small rooms on the second floor where he hosted card games for designated guests and a dance hall on the first floor for the public. Fish sandwiches, sodas, and other beverages were sold upon request. (Courtesy of private family collection.)

SEA BREEZE MAGIC. Remley's Point was home to Riverside, one of South Carolina's most popular beaches. Advertisements from 1939 and later oral histories reveal that Riverside was for blacks exclusively. It had a large dance pavilion, athletic field, bathhouse, and playground. Entertainers included Duke Ellington, Count Basie, Louis Armstrong, B. B. King, and Joe Hunter. Less than a mile down the road, James Brown pounded the ears of partiers at White's Paradise on what is now Fifth Avenue. Riverside Beach is now a gated residential community. Pictured here is Jimmy Gresson of the Duke Ellington Band. (Courtesy of Avery Research Center for African American History and Culture.)

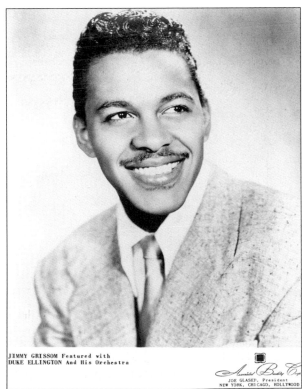

JIMMY GRISSOM Featured with
DUKE ELLINGTON And His Orchestra

JOE GLASER, President
NEW YORK, CHICAGO, HOLLYWOOD

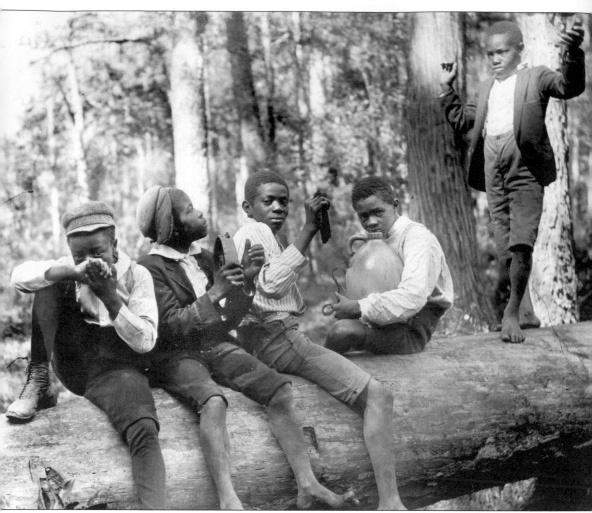

A MUSIC MOMENT. These young African American men pause for a moment to display their musical instruments. Some of them are homemade, while others appear to be of commercial origin. This and similar groups preserved and made popular the African folk songs of Christ Church. There still remains no clear translation of this song that combines spiritual, jazz, folk, and Caribbean flavor:

> Shooly up and shooly down, Shu la, shu la long,
> shooly la all the way around. Shu la shu la long.
> Hambone, hock and greasy rice, make dem young man leave e wife.
> Shu lay, shu lay long,
> Okra soup and tomato sauce, make dem young gal double cross.
> Shu lay, shu la long.
> Shooly up and shooly down, shu lay, shu lay long,
> Shu lay all the way around.

(Courtesy of Charleston Museum.)

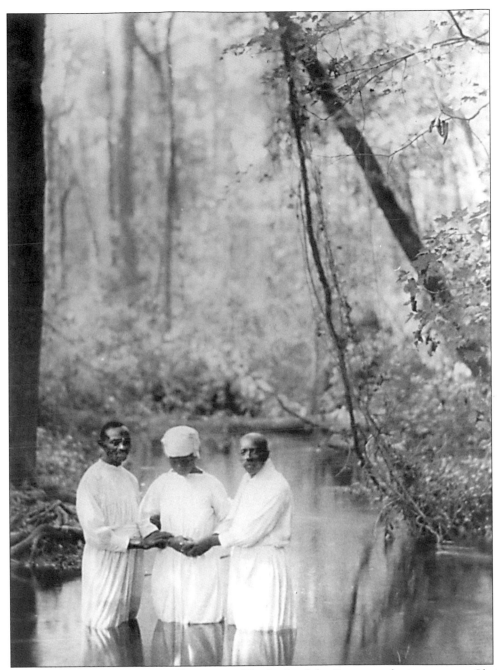

HOLY GHOST–FILLED AND FIRE BAPTIZED. The birth of the Pentecostal movement at Christ Church gave rise to the practice of baptism by total immersion in the river. After receiving the gift of the Holy Spirit, new converts were baptized in the creek at Butler Bridge on Long Point Road. "Take Me to the Water" was sung as the processional started on the road and ended at the edge of the river. As each convert approached the brink, they were received by two deacons who recited, "My dear sister/brother, according to your faith, I now baptize you in the name of the Father, and of the Son, and of the Holy Ghost, Hallelujah and Amen." The person was then dipped backward in the water. (Courtesy of Charleston Museum.)

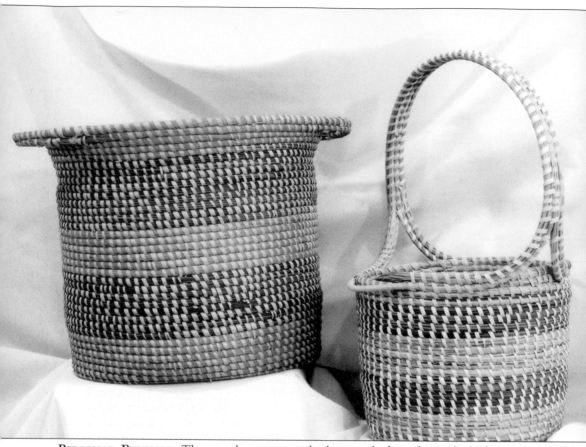

PERSONAL BELONGS. These styles represent baskets crafted in the early 20th century. The artisans were Lavinia Barnwell Nelson and Rosa Barnwell Graddick, two sisters who lived at Boone Hall Plantation in the 1920s.

Five

FLOWERS AND OTHER VENDORS

Before there was a Cooper River Bridge or Highway 17 through Mount Pleasant, or sweetgrass baskets sold along that corridor, there were ladies selling flowers, wild herbs, and elixirs to tourists as well as local residents in the historic district of Charleston. The women were the children and grandchildren of former slaves who worked on Mount Pleasant plantations. Selling flowers was the first attempt by any organized group to seek employment outside the African American community. It was a venture much like that of Harriett Tubman, who followed the North Star. Charleston was uncharted waters in the late 19th century, and not much of it was known by those from rural communities. Most only visited the city to pay taxes and handle legal matters. These female entrepreneurs were willing to get up at 3:00 a.m. and walk seven miles to take a ferry to a place that was completely unfamiliar. The ladies took the city by storm, and their aggressive sales tactics were the source of much controversy and legal debate. By 1947, the *New York Herald* was reporting on their presence in the city. Local headlines included "Negro Women Swarm at Corner to Sell Blooms" (*News and Courier*, 1933), "61 Flower Women Register, Will Wear Bright Bandannas" (*News and Courier*, 1944), "Flower Women Give Distinction to Charleston" (*New York Herald*, 1947), "Street Vendor Problem is Under Study" (*News and Courier*, 1958), "Flower Girls May Move to Chalmers Street" (*News and Courier*, 1958), and "Flower Girls Head for Trouble Again" (*News and Courier*, 1958).

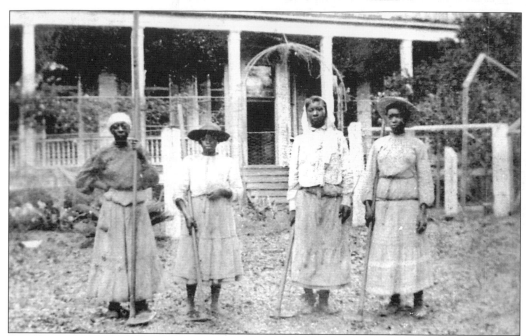

FLOWERS BY DAY; FIRE BY NIGHT. The flower ladies were a resilient, defiant group of business women who, at the beginning of the 20th century, dared to venture away from Christ Church Parish and conduct sales on the streets of Charleston, despite opposition from many in the general population. (Courtesy of Charleston Museum.)

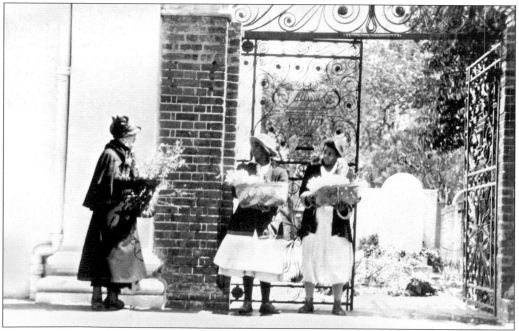

WAR AND PEACE. Flower selling offered Charleston, a city that was racially divided before and after the Civil War, a new opportunity for unity. Street selling encouraged oral communication between two distinct groups. Housewives embraced the flower ladies and became friends and champions of their cause. (Courtesy of Charleston Museum.)

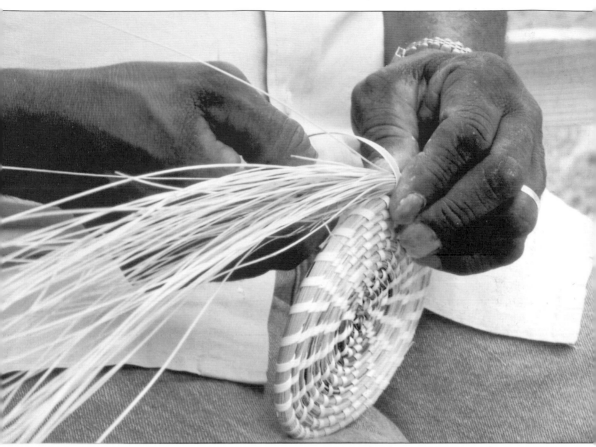

THE MASTER TOUCH. Henry J. Foreman demonstrates the beginning stage of creating a sweetgrass basket. The artisan began by tying a knot using four stalks of pine needles. He used palmetto strips to sew seven rows before adding sweetgrass. This piece could be made into any one of 100 or more styles. The artist also has the choice of making a simple placemat, one of the easier styles.

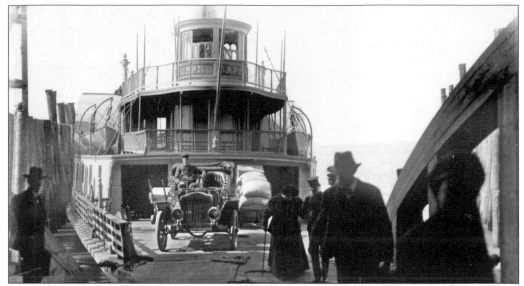

LOOK FOR THE ARISTOCRACY. Mount Pleasant vendors boarded the *Bay Tree, Sappho,* or *Lawrence* at Shem Creek and disembarked at Adger's Wharf in Charleston. The *Sappho* was the most popular because of its size and ability to transport people, vehicles, and cargo. Facilities were assigned according to race; African Americans were assigned the lower deck. Once in Charleston, vendors displayed their wares in heavily traveled areas throughout the historic district. For potential sales, children were instructed to look for the "aristocracy—that's where the pocketbook is." (Courtesy of Charleston Museum.)

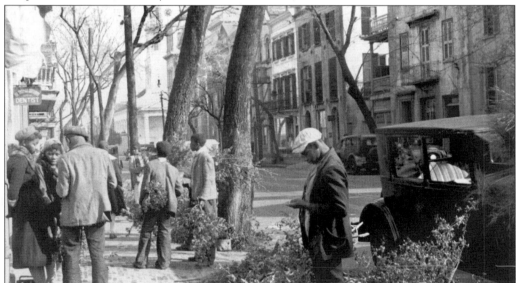

IF IT GROWS, SELL IT. By 1940, the competition in the flower vending industry was fierce. Creative measures were necessary to increase sales. Street bartering and house-to-house sales tactics were initiated. John and Rosalee Manigault and their cousin Freddie Coakley Jr. went weekly with their grandmother Dolly Coakley Heyward to sell to special customers on Church and Chalmers Streets. During the week, they searched the woods to gather all manner of wild flowers, unusual tree branches, and natural herbs to sell on the weekends. (Courtesy of Charleston Museum.)

PENNY WITH A PURPOSE. The flower ladies were fortunate to have allies in the Charleston community. The Garden Club of Charleston and numerous other private citizens were admirers and supporters of the flower ladies and became regular customers. Their Tuesday and Saturday purchases provided income for many families. Tuesday's coffer was designated for insurance and Saturday's went to purchase groceries. The money made in December was primarily for property taxes. Whatever was left was used for holiday treats and to make home improvements. (Courtesy of Charleston Museum.)

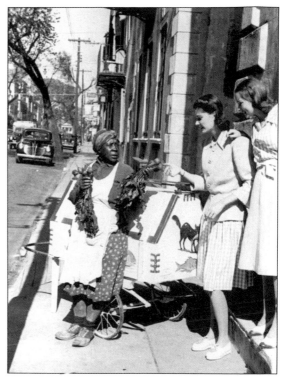

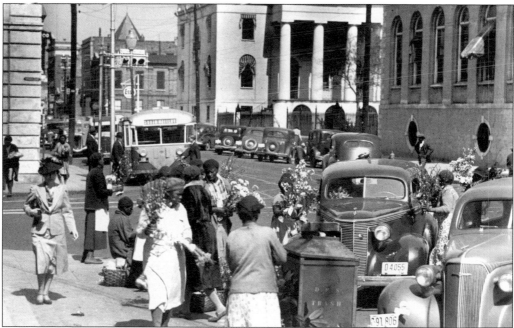

STRUGGLE IS POWER. The year 1944 was the year of struggle for the flower vendors. City Council pressured Mayor Henry Lockwood to ban street sales because of street congestion, aggressive sales tactics, and the unsightly appearance of the flowers and greens. Despite every attempt to remove them, the vendors were resistant to all rules and assertively assumed the designated spots daily. (Courtesy of Charleston Museum.)

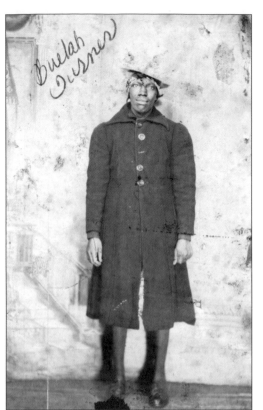

MASON-DIXON COMES TO CHARLESTON.
So great was the flower industry that it often caused traffic congestion at the Four Corners of Law, the famous intersection at the corner of Meeting and Broad Streets separating the post office, St. Michael's Church, city hall, and the courthouse. To prevent this, the city painted a white line on the sidewalk; those failing to remain behind that boundary line were immediately arrested and fined $10. For many, this was equivalent to a week's salary. Buelah Turner, pictured here, was a flower seller from the 1930s and 1940s. (Courtesy of private family collection.)

LINE OF DEFIANCE. In 1944, a police officer was assigned to patrol the flower ladies. They nicknamed him "Fast Foot Brown." The daily challenge was to see who could cross the white line without being seen by Patrolman Brown. Usually, there was a chase to arrest violators. But he was no match for the skilled African runners who often exhausted him on the carefully planned escape route: down Broad to Orange, left on Tradd, then back to Broad again. (Courtesy of Charleston Museum.)

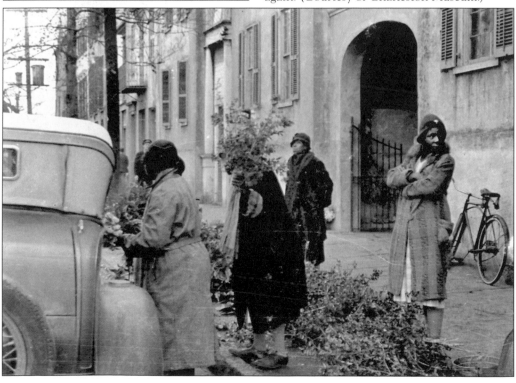

BORN TO SELL. Despite the ongoing political battles, the flower ladies became a favorite city attraction and were featured in magazines, on numerous postcards, and on souvenir items. Their position in Charleston has lasted into the 21st century. Janie Fludd, one of Charleston's most industrious flower entrepreneurs, sold flowers and vegetables in the City Market from the beginning of the 20th century until the 1980s. (Courtesy of Charleston Museum.)

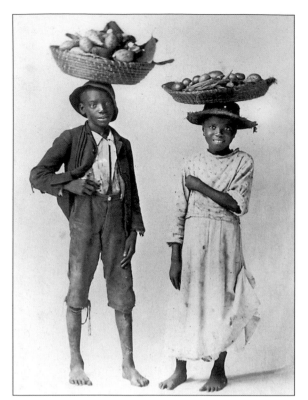

HEADSTRONG. The older adults remained on street corners, while children were sent door-to-door and to regular customers. They were expected to tote containers on their heads while carrying others in their hands, as there was usually little or no time to return to the command post during the day for more flowers. (Courtesy of Charleston Museum.)

ALL IN A DAY'S WORK. The flower ladies became very familiar to the residents living south of Broad Street, an area known for its wealth. In the absence of a full-time housekeeper, the vendors were often offered a dollar to perform odd jobs such as scrubbing floors, sweeping porches and sidewalks, ironing, washing, and cleaning windows. Albertha "Doza" McKnight (pictured here with her husband, Washie Huggins) sold flowers in Charleston for more than 50 years. (Courtesy of private family collection.)

RED BADGE OF DEFIANCE. In 1944, the Garden Club of Charleston and the Belk-Robinson Store united to champion the cause of the flower ladies. In order to appease the complaints of the political foes, they issued ID badges and red bandanas to designated flower ladies and worked with them to keep the streets orderly to minimize the complaints sent to city hall. Here, Dolly Coakley Heyward displays the bandana.

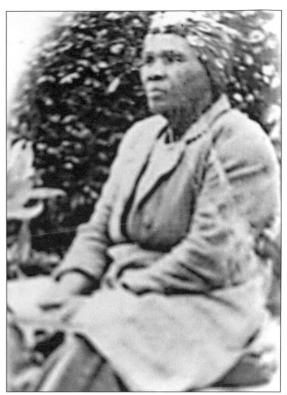

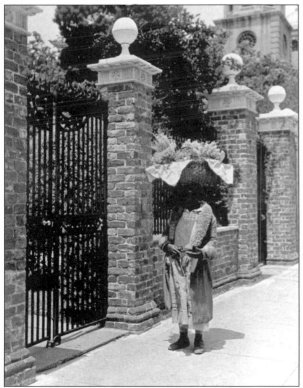

JINGLES RING IN THE COINS. "My name is Yuh go Annie. Got my garden on my head. Flowers. Da is looking mighty fine. Fresh from the vine." Jingles such as this, with carefully choreographed antics, captured the attention of onlookers and potential shoppers. (Courtesy of Charleston Museum.)

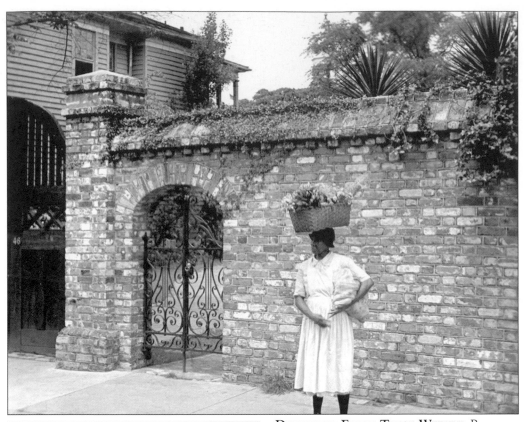

DELIVERED FRESH TWICE WEEKLY. By 1940, house-to-house flower sales were very popular. Fresh arrangements in the foyers and on the piazzas added to the striking beauty of Southern homes. The James Vanderhost House at 46 Tradd Street captures Charleston décor: the brick walls, ornate gates, and courtyard gardens displayed craftsmanship and charm. Built in 1770, it was once owned by artist Alfred Hutty, who often portrayed street vendors in his work. (Courtesy of Charleston Museum.)

TWO FOR ONE. Rosa "Miss Flowers" Manigault and Rebecca "Feetnin" Coakley sold flowers for more than 100 years combined. Miss Flowers was also the community seamstress who created patterns from brown paper bags and sewed them on a pedal machine. Feetnin also worked on the Hamlin Farms. She was known throughout the community for beginning her workday by singing "Real, Real, Jesus Is Real to Me." (Courtesy of private family collection.)

THE TORCHBEARER. Born in 1902, Hagar Smalls began selling flowers in Charleston at a very early age. She and her sisters helped her mother, Maggie Mazyck, sell on South Battery. She continued with her career until she reached her 80s. (Courtesy of private family collection.)

WASTE NO TIME! Isaiah Coakley became the official driver for his grandmother Dolly, Janie Fludd, and many of the other flower ladies when he purchased a gray 1950 Pontiac Starchief after the Loop bus cancelled services for the vendors. His most vivid recollection of the ladies was that they liked fast driving. They wanted to get to the market before any of their competitors. (Courtesy of private family collection.)

FRIEND IN NEED; FRIEND INDEED. Judge J. Waities Waring (left) was considered a friend by the flower ladies of Charleston during their ongoing battle with city hall. He was a federal judge for the Charleston district and the son of one of Charleston's prominent families who lived south of Broad Street. He heard the case of Briggs *v.* Elliott, argued by Thurgood Marshall in 1954, which led to the famous Brown *v.* the Board Supreme Court decision that outlawed the practice of "separate but equal" education in public schools. (Courtesy of Avery Research Center for African American History and Culture.)

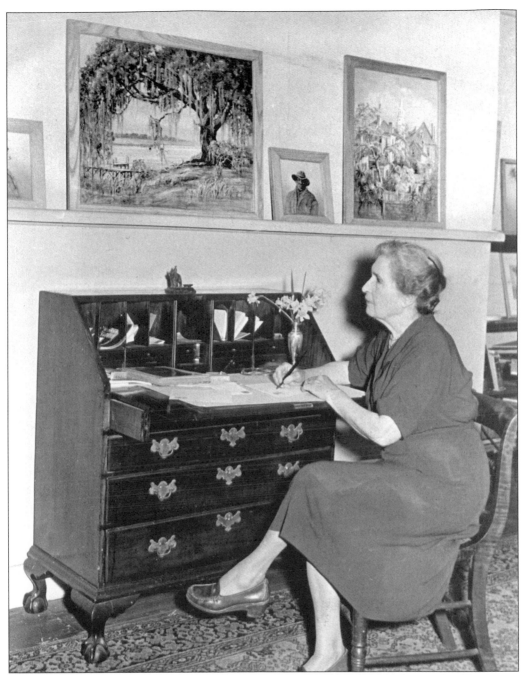

PERMANENT DISPLAY. Elizabeth O'Neill Verner, renowned local artist during the Charleston Renaissance period, painted numerous scenes featuring Mount Pleasant vendors. She remained actively involved with them for more than half a century. In 1979, the flower ladies whom she featured in many of her drawings throughout the years attended her funeral, held at St. Philip's Church. (Courtesy of Charleston Museum.)

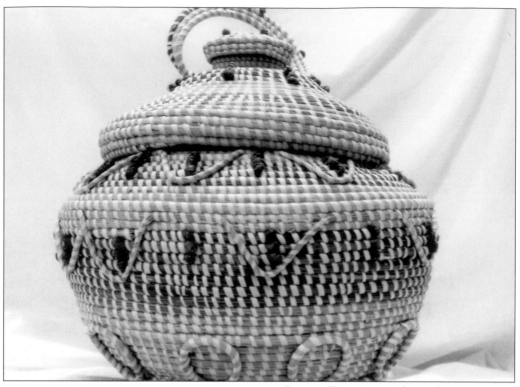

FAMILY TREASURE. This style was designed in the 1990s by Anna Bell Ellis to commemorate the life of the sweetgrass basket maker.

RESPECTED GUIDE. Hattie Seabrook Ellis lived to be nearly a century old. She was an active member of Long Point Missionary Baptist Church who inspired the young people to become active participants in church activities. (Courtesy of private family collection.)

Six

HOMELIFE
House, Food, and Medicine

The freed Africans in Mount Pleasant were very creative in building homes and establishing a place of refuge for their families. Some used crude lumber from the forest; others used bricks from abandoned brickyards. Most of the 1880s structures resembled those on local plantations and West Africa.

The meals were prepared from daily catches of fish, raccoons, deer, squirrels, rabbits, opossums, and wild birds. Chickens, goats, pigs, and cows were raised on the family property and slaughtered on special occasions. They also provided eggs and milk for daily consumption. Freshly grown vegetables and fruits were eaten when available.

The medicines were all taken from wild herbs and animals and a variety of other combinations. There was a person in each community who prepared and exchanged or sold elixirs for a nominal fee. Limited access to doctors and medical care—due to money, transportation, and ancestral beliefs against such things—encouraged the continued use of ancient African remedies that had survived intact through oral tradition and use. Such ancient practices flourished for other reasons, too: roads were poor, and there was no bridge to the city of Charleston until 1929 (and then it cost to cross the Cooper River). Many of the freed slaves remained on plantations or settled in communities that were somewhat isolated from the mainstream. In the early 1900s, there were few physicians in the Mount Pleasant community, and they did not treat African Americans except in extreme life or death circumstances. This forced the African Americans to rely on the herbal medicines and ancient practices. The use of medical doctors became more common with the birth of babies and the immunizations for children in the 1950s.

On some plantations, the education of slaves was permitted in order to help them to become Christians, and for other reasons as well. It was assumed attention to the gospel would make them more obedient to masters and easier to control. Slaves were encouraged to learn such passages as Hebrews 13:17: "Obey them that have the rule over you, and submit yourselves: for they watch for your souls, as they that must give account, that they may do it with joy, and not with grief: for that is unprofitable for you." After the end of slavery, the early schools for freed Africans in the Mount Pleasant area were held outdoors and in servants' cabins. Those who knew how to read and write (forbidden to slaves) often shared their skills with family members and others on the plantation.

As freed slaves established communities, churches were built and missionaries from the North and others sympathetic to the cause of the freed men and women established schools. Students were taught to write their names, scripture, and numbers, and other vocational skills. A vocation was important because it bettered both the individual student and the school: goods made from those classes were often used to support the school.

A female crab is a "she crab," but is the male crab a "he crab?" Not in Mount Pleasant. The Mount Pleasant community probably has the best cooks on earth. Rice, seafood, and wild game make up some of the savoriest dishes. The Gullah cooks pride themselves in being able to take simple ingredients and turning them into a mouth-watering succulent dining experience. Cooking is done slowly and with little or no measurement. Residents of the Lowcountry know that red rice, potato salad, and potato pone separate amateurs and pros. Though shrimp and grits is served in nearly all Charleston restaurants, it is fish and grits that rule in the Gullah household. Both dishes are served with homemade biscuits. Sample meals include stewed chicken, asparagus, cabbage, rice, and pecan candy (from a 1922 Sunday dinner); raccoon, Hoppin' John, collard greens, potato pone, and sugar water (from a 1928 New Year's dinner); rice, collard greens, fried chicken, macaroni and cheese, bread pudding, and Kool-Aid (from a special occasion in 1948); and red rice, fried fish and chicken, string beans, potato salad, and cornbread (from a 1958 church dinner). Lacy Swinton's venison is one of the most desired recipes in the Lowcountry. The fresh venison must be washed several times in vinegar before being soaked in cold water overnight. The meat is then marinated in a special blend of herbs and spices for several hours, then baked slowly until tender. The cooked meat is simmered in a pot of freshly cooked beef stew and served over rice.

IS THERE A DOCTOR IN THE HOUSE? In the absence of physicians, the African American community relied on homegrown medical skill and arts brought to the care of common and life-threatening ailments. These remedies have been passed on from one generation to the next.

COMMON REMEDIES

Sea Lavender	Cough/cold
Fiddler crab juice	Earache
Ho Hound	Fever
Salt Pork/Penny	Infection
Oak Bark	Toothache
Urine	Conjunctivitis
Shark bones	Teething
Lye/hot nail	Tooth Extraction
Green moss	High Blood Pressure
Smoke	Earache
Boiled umbilical cord	Prevent baby from seeing ghosts
Freshly killed frog	Snake bite
Urine	Chill and fever
White potato (worn in shoe)	Fever
Chimney soot	Cramps

The community had several medical practices. If a child failed to walk by a certain age, he or she was buried waist deep for several hours a day in the warm earth. The minerals from the earth were to strengthen the legs. A high fever was cured with a potion made of homemade whiskey and a variety of hot peppers. The sick person had to drink it down as fast as possible and was not to say "thank you" to the provider. A sore throat was cured by plucking certain hairs from the top of the person's head, followed by a small amount of kerosene and sugar applied to the throat. Spider webs were placed in a serious cut.

THE EDGE OF HOPE. Living quarters were scattered throughout the plantation estate. This cabin was the prevalent type on most Christ Church plantations. The long rows of cotton and other crops were planted up to the step of the dwelling to utilize every inch of available space. In the years following 1865, they were rented to task laborers. (Courtesy of Charleston Museum.)

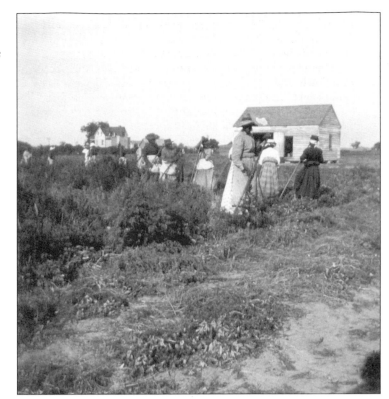

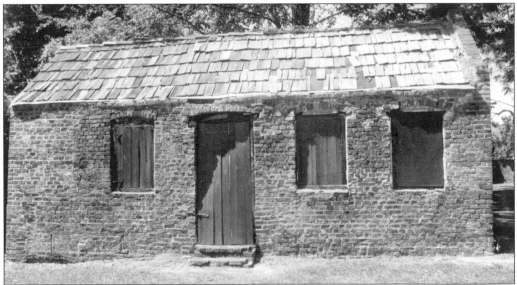

FOR RENT, MULTIPURPOSE BUILDING. The cabins at Boone Hall Plantation have taken on many tenants. Nine brick cabins remain on the famous avenue of the oaks. Built in the early 19th century, they have withstood dozens of hurricanes and a major earthquake. In five generations of usage, they have assumed many roles, including housing enslaved African cotton farmers (*c.* 1800); skilled craftsmen with their families (*c.* 1830); house servants (*c.* 1863); caretakers (*c.* 1899); sharecroppers (*c.* 1920); and imported laborers from Johns Island and other surrounding islands (*c.* 1930).

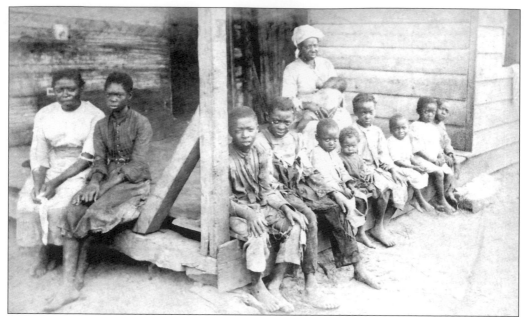

EVERYONE CALLS HER MAMA. By the 1860s, the African family was struggling to survive. Homes were multi-generational and blended. In the Mount Pleasant community, grandparents, children, and grandchildren often lived under one roof, as the devastating blows of slavery often deprived many households of the male presence. (Courtesy of Charleston Museum.)

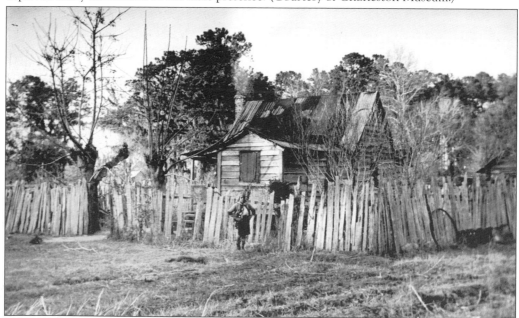

HOME, CASTLE, REFUGE. This house exemplifies the stages of success for a family. The wooden fence served the purposes of both status and security. The midsection resembles the A-frame house of the plantation era, with the modern touch of a front porch resembling Charleston piazzas. A room to the left was most likely added after initial construction. According to Dan Springer, born in 1889, rooms were usually added after an exceptionally good harvest. (Courtesy of Charleston Museum.)

THE AX MAN COMETH. Lawrence Stokes was a highly skilled carpenter in the early 20th century who built homes and additions. He was nicknamed the "Ax Man" because if he had a nonpaying client, he would remove the addition from the home with his ax. He, James Jefferson, and mason Cain Butler built homes throughout the sweetgrass community. (Courtesy of private family collection.)

HOME DON' SEEM LIKE HOME ANYMORE. These wood-frame houses once lined Highway 17 from Long Point to Hamlin Road as a part of the Boone Hall tract. Ida Jefferson Wilson, creator of the first sweetgrass basket stand, rented one of these when she was fired from her plantation job. Lack of use and the expansion of the highway contributed to their demise. (Courtesy of Charleston Museum.)

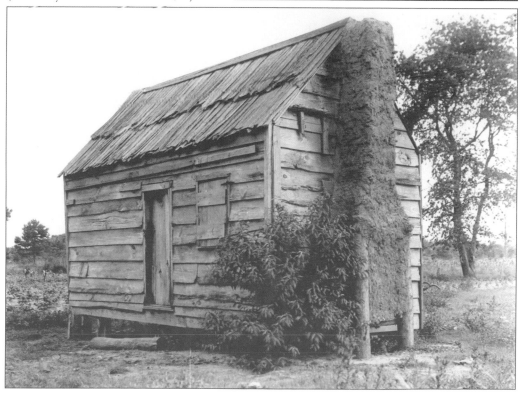

MODERN MARVEL. This early-20th-century home was built by family matriarch Eliza Springer. On her nine-acre property adjacent to Boone Hall Plantation was a pecan grove—called "cannit" in Gullah—and a candy shop. Her son Dan was the official bell ringer at Goodwill AME Church for more than 50 years. The bell was rung just before the Sunday morning services, and it tolled just before funerals as well.

WILD OR TAME, A MEAL IS A MEAL. Since guns and bullets were prohibited to slaves, various techniques were used to trap animals. "If e bun, e done" (if it's burned, it's cooked) was the rule of plantation cooks. Because the smokehouse was not available to servants or slaves, fresh meat was soaked in a tub of salt, then rinsed in cool water. A large fire was prepared in the chimney, where meat was suspended from a hook to cook throughout the day. Slaves working the fields returned periodically to turn the meat to ensure it was thoroughly cooked. (Courtesy of Charleston Museum.)

LONG AND HARD, BUT NOT IMPOSSIBLE. Autumn and winter were seasons of soil preparation for farmers. After the first frost, ground was hoed to expose dormant worms and other pests. The long rows were common on plantations. Field hands were assigned daily portions to be completed by sundown. An area of Woodlawn Plantation off Mathis Ferry in Mount Pleasant was known as "Big Field" and had some of the longest rows in the community. In the 1970s, it became the home of Wando High School. (Courtesy of Charleston Museum.)

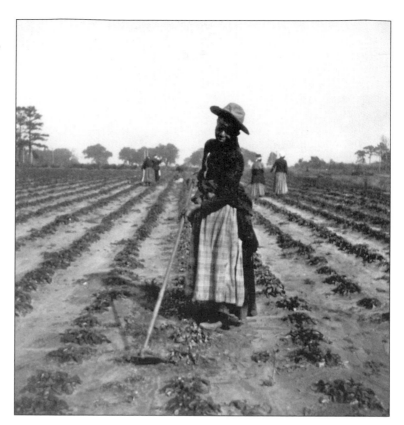

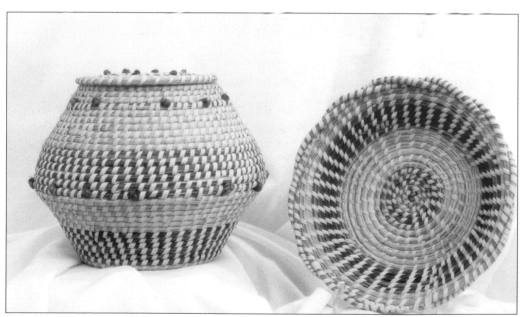

SIGNS AND WONDERS. These two baskets demonstrate the skills of two left-handed basket makers, Celestine Coakley and Alberta Dawson.

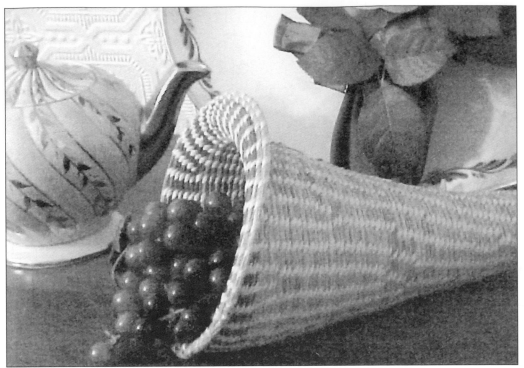

HORN OF PLENTY. This cornucopia was created in honor of the abundant harvest seasons that allowed freed African Americans to purchase property and build homes.

THE CASTLEKEEPER. Many of the historic homes of Charleston are decorated with sweetgrass artwork.

CROWN AND GLORY. Hats made of sweetgrass are worn at many different occasions, as shown here on Rickeeta Coakley.

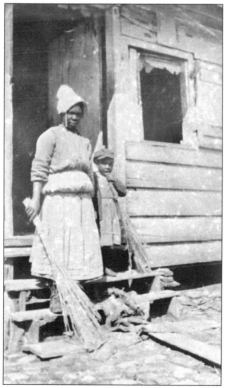

BY WHATEVER MATERIALS AVAILABLE. Newly freed slaves built small homes much like the servants' quarters on the local plantations. Animal hides and wooden shutters were used to cover the windows to keep out the cold drafts of winter. Brooms were made from a grass known as "broom straw" that grows abundantly on the South Carolina coast. It was during this era that many sweetgrass storage baskets were made in the absence of containers needed to store food and other household goods. (Courtesy of Charleston Museum.)

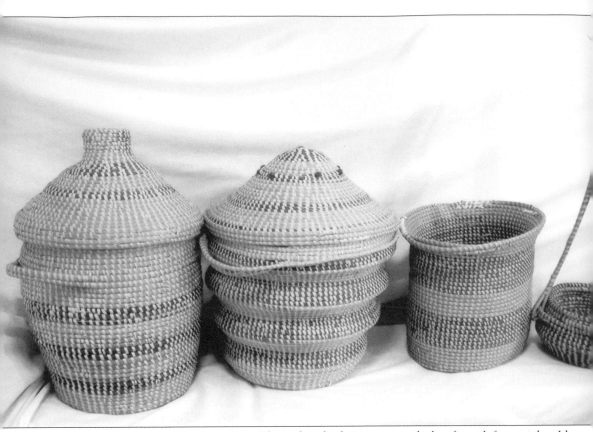

THE TRAILBLAZERS COLLECTION. These four baskets were made by, from left to right, Ida Jefferson Wilson, Camilla German, Rosa Graddick, and Florence Ford, who were all born in the early 20th century and lived on local plantations.

Seven

MIGRATION TO SUCCESS

The infestation of the boll weevil on the cotton crop contributed to a significant decline in the great farms and plantations that existed in the South for more than 200 years. This led to the "Great Migration" for nearly one million Southern African Americans between 1910 and 1930. Those desiring better economic and social conditions migrated to Chicago, Cleveland, Detroit, Philadelphia, and New York in search of work. This migration took those who were accustomed to plantation and farm life to large urban areas with skyscrapers, public transportation systems, and many other modern conveniences. Many took jobs as live-in domestics, railroad attendants, and in other service industries. The majority of those leaving Mount Pleasant relocated to Harlem in New York City; there they kept up contact with each other, which allowed them to interact and marry citizens of their community and maintain the Gullah language and traditions of the Charleston area.

Migration to a better place also encouraged formal education. The jobs in the urban areas required reading, writing, and advanced skills beyond farming and domestic labors. It enhanced the desire for factory work and the seeking of positions in such fields as teaching and nursing. In the early 1900s, the Avery Institute and a few nursing programs were available to African Americans in Charleston. At the same time, the larger cities in the North had many more educational opportunities, and most importantly, many of these programs were held at night, enabling students to work at the same time as going to school. This ignited the interest in parents sending young children to live with older siblings in order to receive academic training. This lasted until the 1970s.

NO CHAINS FOR GRANDFATHER. Amanda Bonneau Coaxum grew up on Boone Hall Plantation. Her father was the caretaker, and they lived in the first cabin nearest the Big House. When she was in her early 20s, she migrated by way of the Clyde Line steamer to New York City, where she worked for the railroad for more than 30 years. She recalls that as a child, an old white gentleman said to her, "Manda, don't ever let anyone tell you that your grandfather was ever in chains." For years, this statement remained a mystery, though she was always troubled by it. It was not until she was much older that she was able to figure it out that he was talking about slavery. (Courtesy of private family collection.)

WE DANCED ALL NIGHT. Douglas Coakley found excitement and glee in New York City. He left Mount Pleasant in the 1930s and immediately found employment at the U.S. Postal Service, where he worked as a truck driver for more than 40 years. (Courtesy of private family collection.)

FROM PLANTATION TO GRADUATION. Irving Stokes spent his early years working as a cook's helper to William Seabrook at Boone Hall Plantation. His duties included toting water from the pump, gathering wood for the fireplace on the porch, preparing vegetables to be cooked, and doing whatever else he was called upon to do. He recalls vividly the day his grandmother told him that he was going to New York to live. Arrangements were made with Mr. Ford, a man from Charleston who regularly transported people to the North. The fare was $8 for the three-day journey. They made designated stops in North Carolina, Virginia, and Maryland. When he got out of the car, he was greeted by his cousins, who laughed hysterically because he had his new shoes strung across his shoulder rather than on his feet. He soon found that Harlem was very different from the plantation. Irving later entered the U.S. Army, and upon discharge, he was trained in electronics at Delahanty Institute. (Courtesy of private family collection.)

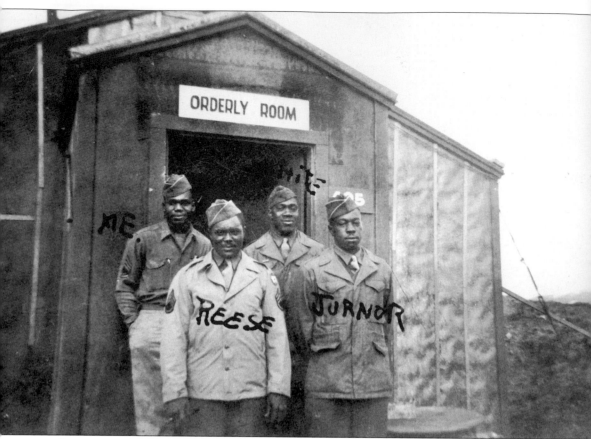

COMMUNITY LEGACY. John Dilligard (back left) served in the U.S. Army during World War II and was awarded the Bronze Star for his participation in the Central Burma campaign. He was assigned to the 60th Ordinance, an all "colored" troop. While fighting in Europe, he and friends organized social activities and provided homemade beverages for the troops in Tent 27, known as "Little Las Vegas." They were visited by boxer Henry Armstrong and football great Kenny Washington. John was aboard the USS *General R. Brooks* when it nearly sank during a storm in the Mediterranean in 1945. (Courtesy of private family collection.)

THREE THE HARD WAY. Sisters Christina (left) and Romelle (right) Graddick and their cousin Harriet Barnwell (center) decided that they would hit the road for New York in order to make a better life and help parents with younger siblings. This was a common practice for those desiring to improve home conditions, since so many from the sweetgrass community were financially challenged. They spent decades in New York in various professions; all returned to continue their first love, sweetgrass basket making. (Courtesy of private family collection.)

NEW YORK MEANS FUN. The desire to travel North was usually inspired by stories told by visiting friends and relatives. Mae Bell Foreman (center) is intrigued by stories told of the Apollo Theater, Coney Island, and the subway system by Leroy and Viola Coakley. Former residents of Mount Pleasant historically made the pilgrimage home twice a year, at July 4 and at Christmas. They brought gifts of toys and clothes and took back field peas, salt pork, and link sausages. (Courtesy of private family collection.)

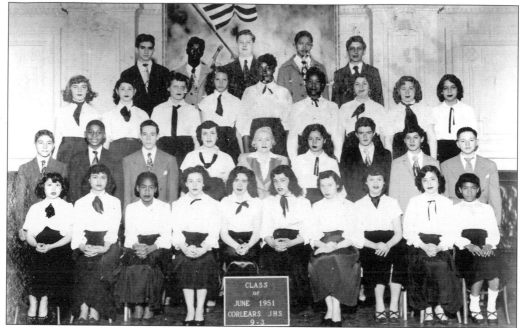

ALL TOGETHER AS ONE. Ida Green (fifth from left, second row from top) migrated with her family to New York as a preteen in the late 1940s. In Mount Pleasant, she attended a small three-room schoolhouse in the Four Mile community. Much to her surprise, her new schools in New York were multiracial. (Courtesy of private family collection.)

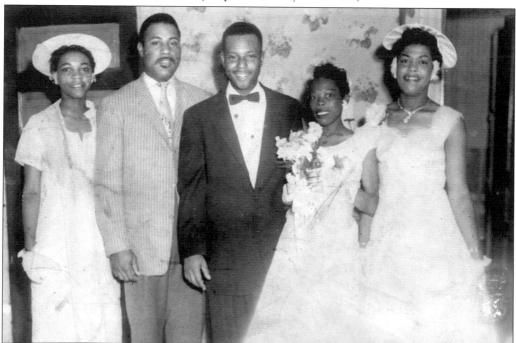

FROM FIELD TO MARRIAGE. Annie Waring (second from right) planted and sold flowers with her mother on Broad Street. She decided to elope and move to Pittsburgh, Pennsylvania. (Courtesy of private family collection.)

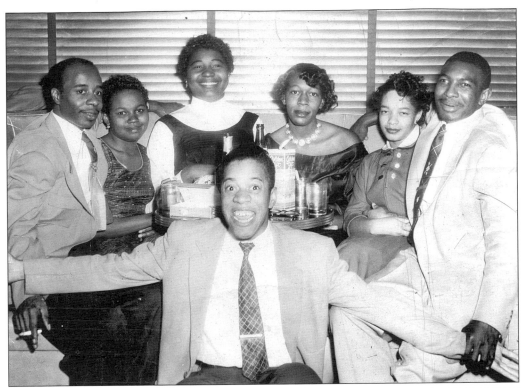

MAIDS' NIGHT OUT. For Charlestonians in Harlem, 596 Lenox Avenue was a familiar location in the first half of the 20th century. The Savoy Club became the gathering place on Thursday nights. This was when people who left the South to work as live-in maids gathered to socialize. They introduced the Charleston and the Lindy Hop to people in the Big Apple. Performing at the Savoy were jazz greats such as Benny Goodman, Cab Calloway, and Duke Ellington. These Lowcountry folks made "Charleston" a household word in New York City. (Courtesy of private family collection.)

FROM LAING TO LUXURY. Jerodene Ellis learned grace and charm in her home economics class at Laing High School in 1947. She took the skill to Philadelphia, where she lived for 37 years before returning to Mount Pleasant. She was able to obtain a business and public administration degree from Temple University. She was employed by the City of Philadelphia as a personnel specialist, supervising the unit developing the civil service examination. (Courtesy of private family collection.)

ROOM FOR ALL. Willie Mitchell left Mount Pleasant as a child with his mother and older siblings in search of a better life in the North. He met with great success and did not forget those he left behind. He opened the doors of his home to those wishing to relocate to New York who needed help finding a job. (Courtesy of private family collection.)

Eight

SCHOOL
The Institution of Hope

The Negro Code of 1740 shaped the education of enslaved Africans in America for more than a century. It was on Sunday, September 9, 1739, in the Stono community, less than 20 miles from Mount Pleasant, that the bloodiest slave insurrection occurred. Armed with guns and knives, Africans killed more than two dozen white men, women, and children. As a result, the state of South Carolina passed what is now known as the Negro Act of 1740. It was not until 1865, and after the signing of the Emancipation Proclamation, that those of African descent received academic instruction publicly.

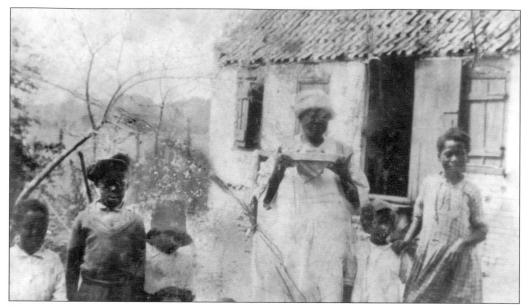

PLANTATION INSTRUCTION 101. Oral historians and written documents proclaim the late 19th century as the beginning of institutions of education for training freed Africans in the Charleston area. Classes were held in newly constructed one-room schools, outdoor settings, churches, and even plantation cabins. After freedom, many families stayed on the plantations. Frankie Bonneau taught those who stayed on Boone Hall on Tuesday nights in his cabin nearest the Big House. (Courtesy of private family collection.)

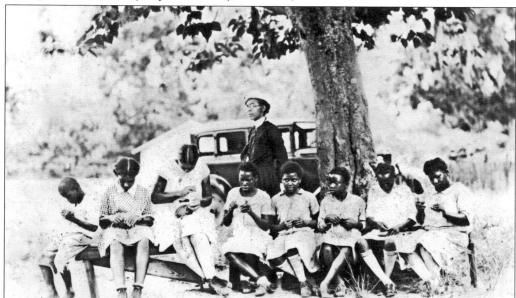

TRAINING DAY. The Philadelphia Friends Association for the Aid and Elevation of the Freedman, along with many different abolitionist organizations, came to help compensate for the treatment of the enslaved. Many different teacher-training programs, such as Avery Institute in Charleston, also emerged. Many of the teachers came to the Mount Pleasant area to work in Laing and other community schools. Students were taught the basics of reading, writing, arithmetic, sewing, cobbling, millinery, and woodwork. (Courtesy of Charleston Museum.)

BRING YOUR OWN WOOD, IF YOU PLAN TO KEEP WARM. The Old Gregory School was one of the first one-room schools in Mount Pleasant to educate freed Africans. The school eventually grew to three large rooms, housing two grades in each room. The students could obtain an eighth-grade education and then transfer to Laing School if they desired a high-school diploma. By the 1930s, the Charleston County School District supplied wood and coal in winter, but students had to bring in extras in order to keep warm. (Courtesy of Charleston County School District.)

RAY OF HOPE. Sweetgrass lamps were first introduced in the 1980s, as decorators used them to accentuate beachfront homes.

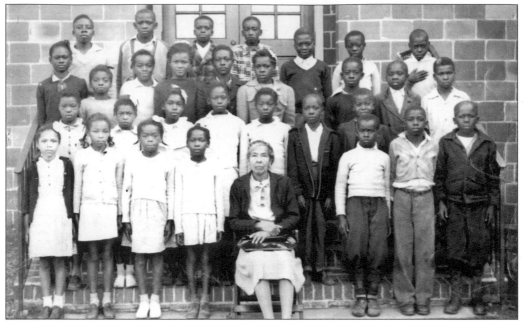

ALMOST FROZEN. Regarding Laing School, Al Conyers recalls, "We walked from Green Hill to Laing School everyday. In the winter it was so cold that we could hear the frozen ground cracking beneath our feet. If it rained, icicles formed on our jacket sleeves. . . . When we got there the first thing we had to do was say our prayers; then we repeated either the 1st, 8th, or 23rd Psalm, followed by the pledge and some singing. When Mrs. Johnson tapped her ruler it was time to sound those vowels." Mrs. Johnson is seated center with a class from Laing School. (Courtesy of private family collection.)

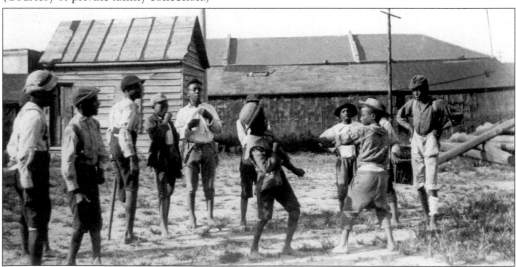

THE BIRTH OF COMPETITIVE SPORTS. The school days were long and offered a mid-day break where girls and boys engaged in organized play. The most popular game in the early 20th century was L'O, a game that stemmed from the enslaved on Mount Pleasant plantations. The children sang, "L'O, Talley Low, L'O, Talley L'O. You don't know, Talley Lo, I got a home in Baltimore." The person doing the singing had to chase and catch someone in the circle. Some groups pronounced it "Dally Lo." (Courtesy of Charleston Museum.)

MISSING IN ACTION. Pictured is Laing High School's class of 1947, where women outnumbered men by a three-to-one margin. By the age of 12, many young boys were still going to work in the fields and local docks. (Courtesy of private family collection.)

THE MIGHTY THREE. The old Laing School conducted all of its graduation ceremonies at Friendship AME Church before the new school was built on King Street. Graduation ceremonies included three nights of activities: the baccalaureate on Sunday afternoons, class night at the school during the week, and commencement the following Sunday afternoon. The school continued with the tradition until 1970. (Courtesy of private family collection.)

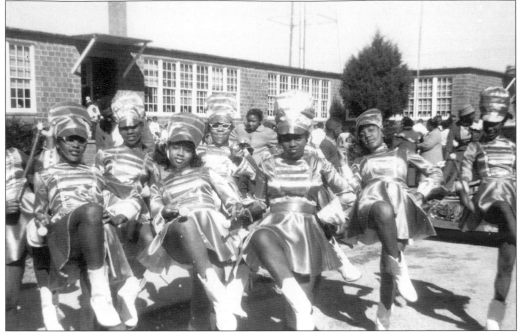

TRUE TO HER. The first band was organized under the direction of Fletcher A. Linton at the new Laing School; those following Linton were Melvin Cunningham and James Jenkins, son of community activist Esau Jenkins. The school's colors were blue and white, and the mascot was a Wolverine. Ruby Cornwell and Grace McKnight wrote the alma mater: "Hail to the name of Laing. To her we'll all be true. Hail to our alma mater, dear. Hail to the white and the blue." (Courtesy of private family collection.)

WHERE THE GIRLS ARE, THE GUYS HAVE BEEN. Francis Saunders (fifth from left) was captain of the first organized girls' basketball team at the old Laing High School, coached by Riley Roper, who was also the home economics teacher. Saunders later attended college and returned to teach English, French, and social studies for more than 30 years. For her outstanding teaching skills, she received an award as an outstanding young educator by the Mount Pleasant Jaycees. (Courtesy of private family collection.)

BUS TO SUCCESS. The "new" Laing School opened its doors to all African American high school students in Mount Pleasant in 1954. The yellow buses, driven by male students, transported students from the Cooper River Bridge to the 10 Mile community, as well as from Sullivan's Island. The new extracurricular activities included band, cheerleading, and organized football and basketball teams. The number of those obtaining a high school diploma increased significantly. Wilhelmina Coakley Washington is pictured here. (Courtesy of private family collection.)

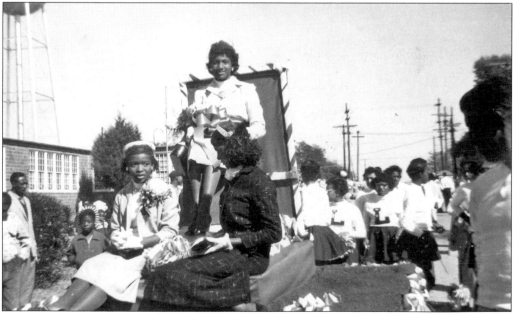

FUN FOR ALL. By 1957, the Laing High homecoming parade became a community event. Contestants for homecoming queen were selected from each class. The class raising the greatest amount of money saw its queen enthroned. Raffles, dinners, and candy sales were the primary source of funds. Proceeds from the event were used to finance the athletic and music departments. (Courtesy of private family collection.)

MEMBERSHIP CARD
NATIONAL CONGRESS OF COLORED PARENTS and TEA

National, State and Local Mrs. CHAS. L. WIL

19 **55**

President

National Office: 123 S. Queen St., Dover, Delaware

Name **Mrs. Janie Coakley**
Address **Rte. Mt. Pleasant, S.C.**
State President **Zack Townsend**
Local President **Rev. D. German**

NEW SCHOOL AND NEW OPPORTUNITIES. Jennie Moore School was the elementary school built in the early 1950s to support the new Laing High School. The younger students were now privileged to interact with students from other communities. The school brought an end to the one-room schools and offered the children of the sweetgrass basket making community a facility with indoor restrooms, telephone services, steam heat, single graded classes, and brand-new textbooks stamped "For Use In Colored Schools Only." The newly formed PTA offered parents the opportunity to actively plan for their children's education. Florence Bostic, Ruth Singleton, Mildred Huger, and Helen Vanderhost, all products of the community, were teachers. Rella Coles was the dietician. (Courtesy of private family collection.)

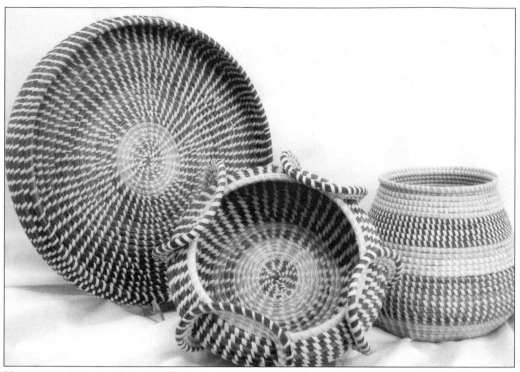

KEEPER OF SECRETS. Many different containers were used to store rice.

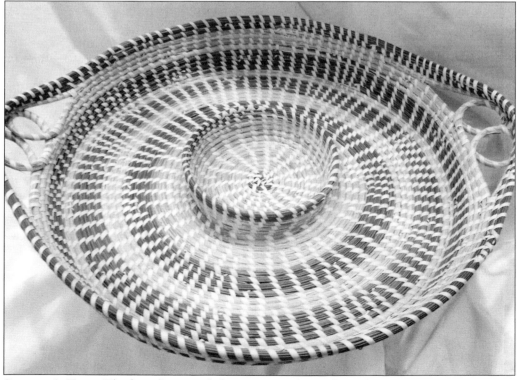

SERVANT'S TOOL. The *hors d'oeurves* dishes were popular in the 1960s.

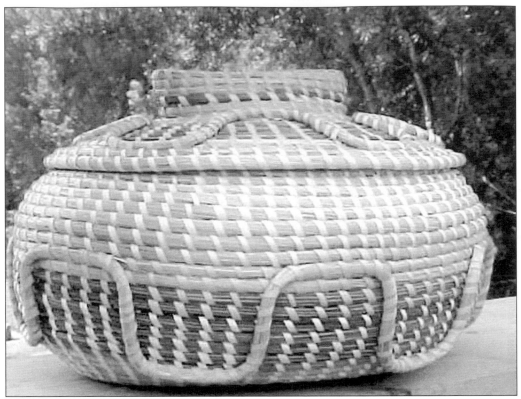

THE KING'S CHAMBER. Exquisite estate pieces such as this are made at the customer's request.

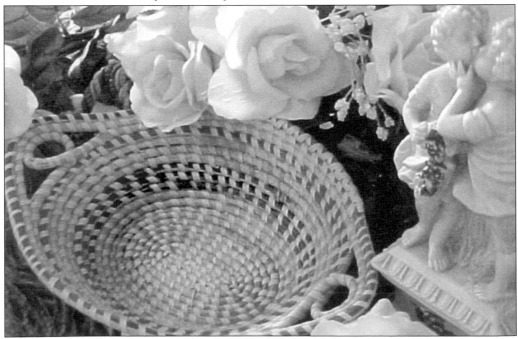

CAPTURED BEAUTY. The breadbasket was one of the popular styles of the 1930s. Many variations are made today.

Nine

CHURCHES AND
RELIGIOUS TRADITIONS

Mount Pleasant is one of the few places where 18th-century African American cultural and religious practices lingered. They survived, in fact, into the 1960s. Those wanting to become a Christian had to go through a process called "seeking." This required an individual to go into the woods at midnight, and at dawn to seek the presence of the Lord. It was believed that God manifested himself in the form of a dancing star. The person desiring to be a Christian also had to have a special dream that would be analyzed by a council of elders called the jurymen. The individual was taught how to pray by a "seeking mother" or a "spiritual father," who were respected members of the community. If the seeking experience and dreams were judged to be noble and favorable, the seeker was then extended the right hand of fellowship to join the church or body of believers. The dreams that led one into church membership were never to be told to anyone who was not a believer or Christian. During the seeking process, the individual was given little or no food to eat. Seeking usually lasted from three days to three weeks and usually was completed by the age of 12. According to traditional African beliefs, the child's mother carried the sins of her son or daughter until that age.

The birth of the Pentecostal movement contributed to many changes in the church. Converts strived to attain spiritual gifts rather than maintain African traditions that involved such practices as seeking. The new emphasis was on water baptism and scripture. Ironically, the Pentecostal church retained use of the spirituals while the Baptist and AME (African Methodist Episcopal) churches started using printed hymnals and gospel music. The prayer meetings held by all three denominations had the common element of spiritual, as the meetings were usually led by the older members of the church, who were accustomed to the "old ways" of worship that included the singing of spirituals.

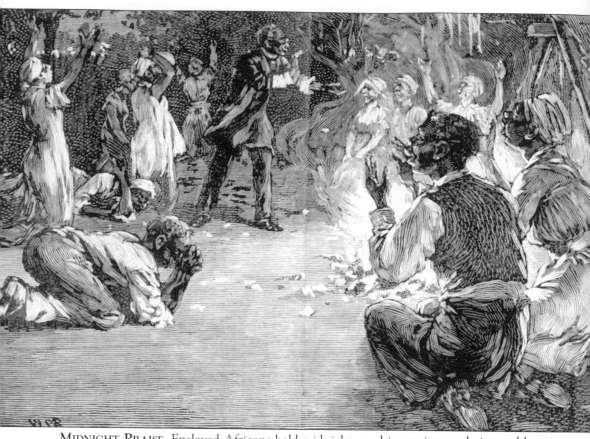

MIDNIGHT PRAISE. Enslaved Africans held midnight worship services at designated locations deep in the heart of the woods called the "howling wilderness." Because their masters forbade organized worship and unescorted travel, night movement of slaves was severely restricted. The females and young children preceded the entourage leading to the "praying ground." Older males who tied branches around their feet to erase their tracks followed them. Services were loud and emotional; therefore, they had to get as far away from the plantation as possible. A "camping ground," a "special place," or "praying ground" was a seeker's personal place of prayer. The location was used until he or she was examined and fellowship extended into church membership. If the seeker lost faith and became afraid to pray in the wilderness, the elders "turned him back" until he was ready to face the danger of the wilderness.

NIGHT TELLS THE STORY. In the mid-19th century, freed Africans designated two nights for prayer services: Tuesday nights were for sinners and Thursday nights for Christians. At Boone Hall Plantation, these services were held at Caroline (shown here) and Frankie Bonneau's cabin, the first nearest the Big House. Walter Jefferson led the opening hymn, "A Charge to Keep I Have," while Frankie conducted the prayer. Children were also taught to write their names on Tuesday nights. (Courtesy of private family collection.)

THE ROYAL FAMILY. The official right hand of fellowship in the organized local church was extended at a Sunday service when the pastor was present. Goodwill AME Church, located in the sweetgrass community, was home to many believers. It was founded in the mid-19th century and bears the Springer name on its original deed. (Courtesy of Goodwill AME Church.)

FACE THE SUNRISE AND DON'T BE AFRAID. Geneva Gaillard, renowned seeking mother of the Christ Church community, interpreted dreams and led seekers through the howling wilderness for more than half a century. Born in 1902, she felt the gift and calling on her life at an early age. Her basic instructions to seekers were "Don't be afraid! Face the sunrise and don't give up!" (Courtesy of private family collection.)

JUDGED WORTHY. Rev. Joseph Turner was a juryman and helped to examine the dreams of hundred of seekers in his more than 60 years as a leader and local preacher. For decades, he led the prayer service at Goodwill AME Church. (Courtesy of private family collection.)

WHEN STARS RUN, CHRISTIANS ARE BORN. Edward Singleton was converted in a seeking experience in 1915. It was then that an angel appeared to him in the wilderness and sang a song that has become the Christ Church Parish community anthem:

Mary weep, Martha mourn
(Repeat)
Mary weep over Lazarus grave
Go little lamb (golden) gonna shine.

Watch that star see how dey run
(Repeat)

Star run down to the setting of the sun
Go little lamb (golden) gonna shine

What-cha gonna do dat day?
(Repeat)
Judgment day is a rollin long
Go little lamb (golden) gonna shine.

(Courtesy of private family collection.)

FIRE IN MY BONES. Marie McKnight Rivers, the first female pastor in Mount Pleasant, changed the course of religion in the Christ Church community when she founded the Garden of Prayer Pentecostal Church. She was a worshiper at Goodwill AME Church until a near-death experience in 1930 had her bedridden for several months. It was then that God called her to preach. Influenced by Bishop Charles Mason of the Church of God in Christ, she taught the doctrine of water baptism, speaking in tongues and "tarrying" for the indwelling of the Holy Spirit. These new teachings led to the decline in the practice of seeking in the wilderness. (Courtesy of private family collection.)

SISTER TO SISTER. Sis Mary Jane Simmons and Sis Christina Graddick represent the new converts in the Pentecostal movement. The women wore white dresses to church with starched hats called crowns of glory. White was required for Sunday services, but other colors were permitted during the week. (Courtesy of private family collection.)

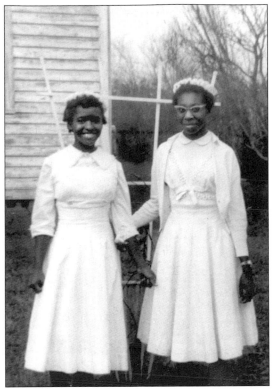

MIGHTY WARRIOR. Rev. Victoria Washington (far left) was a seeking mother for more than 70 years. She became the first ordained female AME minister in Mount Pleasant. She endured great persecution, as there were many males who refused to accept the Holy Communion that she served. (Courtesy of private family collection.)

SOMETHING OLD, SOMETHING NEW. Several quartets were organized in the Mount Pleasant community in the 1930s. This led to the preservation of the praise songs sung at local prayer meetings and also resulted in the blend of recorded gospel songs with those of the local community. Included in this image are Abraham Fordham and Louis Johnson. (Courtesy of private family collection.)

FLYING HIGH. Louis O. Johnson graduated from the Avery Institute and Hampton Institute and received flight training at Tuskegec Institute with the 332nd Air Group of the U.S. Army Air Corps. After working for the postal service, he was pastor of two AME churches for 32 years. (Courtesy of private family collection.)

Ten

JUST ORDINARY PEOPLE

They were just ordinary people doing ordinary things, but through their lifestyle they were able to preserve the history and culture Africans brought to America over 300 years ago. Charles "Hemp" Fludd became a major landowner and worked diligently to improve the lives of African Americans in the village. Elizabeth Wilson, a pioneer flower lady, farmer, and quilt maker, lived to be 103 years old. Benjamin Bailey taught for over 40 years. Hardy Sanders worked at the Johnson Funeral Home and with community activist Jennie Moore, for whom the local black elementary school was named. Rev. Daniel German preserved the legacy and integrity of the burial society in the sweetgrass community for more than 75 years. Patty Manigault, a freed slave who lived for more than 100 years, bore the scar of slavery on her forehead and insisted upon talking to the children about the hardship of living as a slave in Florida before being sold to the Hamlin Plantation. Bently Daniel taught the Ten Commandments to hundreds of children. Old Lady Lucy could carry a bucket of water on her head and two in her hands, never cut her finger or toe nails, and never wore shoes. Rena "Big Mama" Campbell gave away more than 200 quilts in her lifetime. Lillian Holmes devoted her life to children. Maggie Mazyck taught her children the art of selling in the market the resources provided by nature. Annie Ola Nelson was the good Samaritan of Snowden. Geneva and Joe Heyward sacrificed all they had for New Hope Church. Rev. William Jackson preached to three generations in the 1940s, 1950s, and 1960s. Gurley Ellis was the guiding light in the Snowden community. Elijah Smalls, Chris Major, Alfred Wilson, and Len Major were members of President Roosevelt's Civilian Conservation Corps. Geneva Mazyck made blackberry dumplings for everyone in the Seven Mile community. Maggie "Blossom" Jefferson, Edith "Missy" Springer, and Mary Gourdine demonstrated ancient African farming techniques on the Hamlin Farms. Nancy McRae encouraged basket makers in the craft shows. Mattie Gillard fed anyone who crossed her doorstep. Isaac Boston insisted on better roads for the rural areas. This is certainly dedicated to all the grandparents who loved, babysat, and spanked the entire neighborhood during the summer; all those whose fruit trees were robbed; and all those unnamed Africans who contributed to the rich heritage we enjoy in the Gullah culture of the South Carolina Lowcountry.

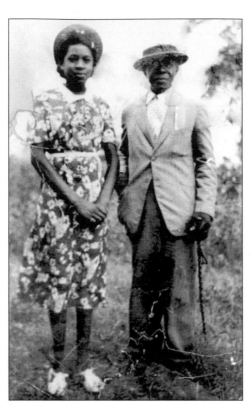

COMIN' FOR TO CARRY ME HOME. Sandy Singleton, a former slave of the Christ Church plantations, lived to experience freedom in a place that once held him captive. He was later employed at Boone Hall Plantation as a night watchman. Sandy is shown here with his granddaughter Annie. (Courtesy of private family collection.)

SEVEN-YEAR ITCH. Charlotte Grant, born 1841 on the Boone Hall tract, lived 98 years and was able to provide an oral account of plantation life to her children and grandchildren. She told the legend of the headless slave who guarded plantation treasures. The lore says that every seven years he returns to tell favored family members where Civil War treasures are buried. The person is required to keep the gift a secret. If he tells, the earth takes back the treasure. (Courtesy of private family collection.)

THE SECRET QUESTION. Louisa Scott McCall was born in 1863. "Ma, weh da sun go when e go down in da ground in the evenin time?" her youngest daughter Adline asked her in 1910. "Chile, da sun don go ein da ground. It go all ober da wirl ta shine on other chillen," she responded. Both Adline and Louisa were babysitters to National Heritage Fellowship award winner Phillip Simmons, the renowned blacksmith of Charleston. (Courtesy of private family collection.)

ONLY THE BEST. Alice Singleton Jenkins (February 1890–November 18, 1974) was a great cook known throughout the town of Mount Pleasant for her cinnamon rolls. She cooked for the officers at Fort Moultrie on Sullivan's Island for more than half a century. The fort had seen many soldiers over the years, including writer Edgar Allan Poe, who lived there while serving in the army. (Courtesy of private family collection.)

THE LAST PAYCHECK. Betty Graddick Washington was among the last African Americans to live on the 200-year-old Laurel Hill Plantation in the Phillip community. Her family contributed greatly to the success of the plantation farm and pecan grove. Betty remained until she met and married David Washington, who took her to live on Highway 17. He helped to construct the Cooper River Bridge that connected Mount Pleasant to Charleston. (Courtesy of private family collection.)

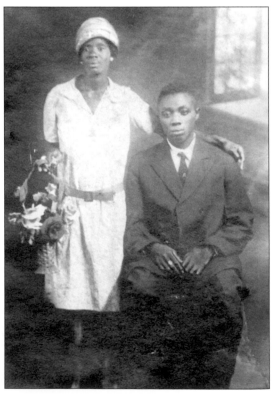

MY FATHER'S KINGDOM. Ruth and Ferdinand Coakley are pictured in 1915. Ferdinand Coakley, born in a humble cabin on Hamlin Beach, moved to the village as a teenager, married his teenage sweetheart, and opened a small grocery store on Venning Street. "My children," he vowed, "will have more than I did." He was able to provide a college education for his children. (Courtesy of private family collection.)

FROM THE GOVERNOR'S MANSION. Maggie Cooper (pictured here with her husband) and her mother, Celia, were caretakers and historians of the Charles Pinckney estate, built in the 18th century. Charles Pinckney was four times the governor of South Carolina, a member of the Continental Congress, and a signer of the U.S. Constitution. Celia lived on the property from the late 19th century until the 1980s. It was understood that she could reside there until her death. (Courtesy of private family collection.)

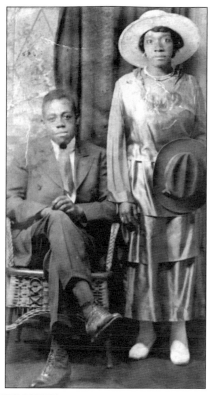

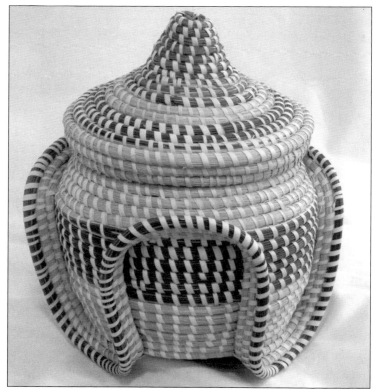

THE CHALLENGE COURSE. Temple jars, which resemble the old oriental temple jars, are used by decorators to compliment early American as well as oriental décor.

FREEZING COLD HOT WATER. In 1913, at the age of 13, Plum Washington, born Nathalee Wright, began working in the oyster industry. She was paid 60¢ for a day's work, which began at 7:00 a.m. Oysters were steamed and placed on tables before the shuckers. On cold days, the steam turned to icicles on the workers' hands. Sharp oyster shells often inflicted serious gashes. Miss Plum, an avid basket maker and former flower lady who lived to be nearly 100, said it was prayer learned in the wilderness that brought her through. Plum's daughter, Martha Lee Washington, is shown above on the left. (Courtesy of private family collection.)

THE COUNTRY HAS NEED OF THEE. Abraham Fordham graduated salutatorian from Laing High School after being retained in the fourth grade. He attended South Carolina State College but was drafted during World War II, just two months before graduating with a biology degree. While stationed in Virginia, he read in an article that he had been awarded his degree in absentia. Fordham returned to Mount Pleasant and taught in the local schools for more than 30 years. (Courtesy of private family collection.)

WALK ON THE WILD SIDE. Theresa "Love" Manigault and her brother Ike began selling sweetgrass baskets, *c.* 1918, to a merchant on East Bay Street who shipped them to New York. They got up at 3:00 a.m., walked seven miles to catch the ferry to Charleston, sold their baskets, and returned home to perform chores. Love's three children, John, Rosalee, and Lillian, became champion vendors in the flower industry. Love is pictured here with her granddaughter Mary Pearl Manigault. (Courtesy of private family collection.)

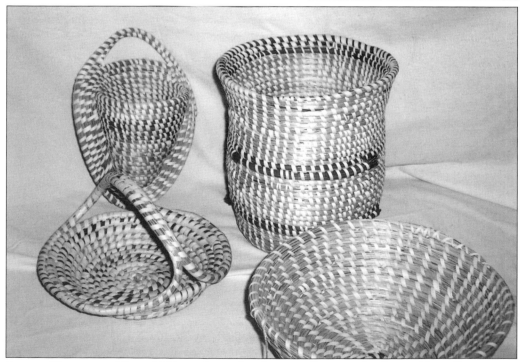

FAMILY HEIRLOOM. These 1930s traditional styles are still in popular demand by collectors.

ICE TO ICE SERVICE. Before the arrival of electricity in the Mount Pleasant community, Daniel German sold ice from his wagon, which he also used to convey the dead for the Johnson Funeral Home. He later opened one of the first gas stations owned by an African American in the area. (Courtesy of private family collection.)

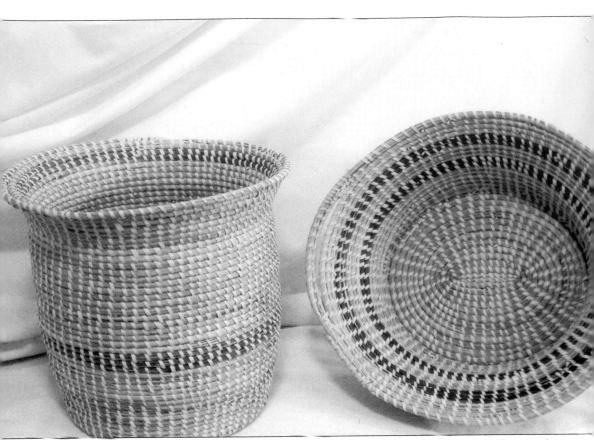

THE OFFERING. These two traditional styles are used as offering pans in churches in the Charleston area.

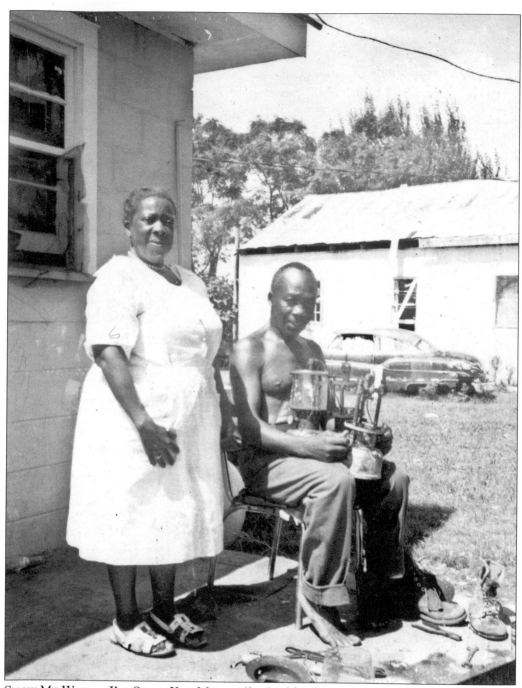

SHOW ME WATER, I'LL SHOW YOU MONEY. Ike Coakley, known as the "Oyster Man" of Mount Pleasant, proclaimed that he knew the Hamlin Sound better than any man alive. He provided oysters for local events from the 1920s until shortly before his death in 1997. "The crick [creek] is my friend," he always said. Ike is pictured here with his wife, Martha Manigault Coakley. (Courtesy of private family collection.)

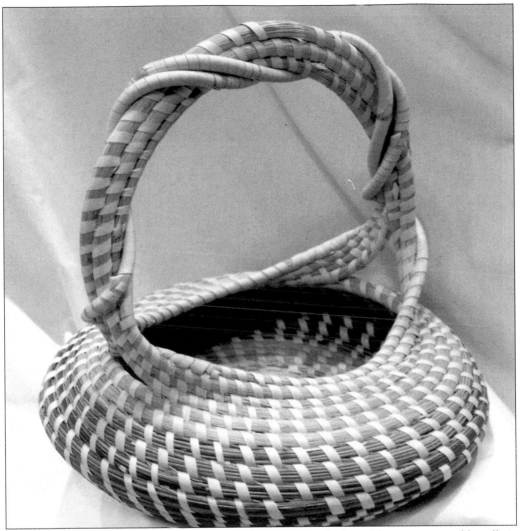

PATH OF TEARS. This basket is similar to 18th-century egg baskets. The wrap-around handle is a 21st-century style similar to those still made in West Africa.

LOOKING GOOD. Solomon Grant, shown here with his wife, Martha Milligan Grant, worked with his father, Jack, and brother Marcey to help all in the community look pressed and at their very best. Before the advent of electricity, the Grant family provided the coals that were used to fuel the irons. They made door-to-door stops on Saturday afternoons so that the garments would be pressed and ready for Sunday church. Martha grew up on Boone Hall Plantation. (Courtesy of private family collection.)

HOUSE OF REFUGE. Maggie and Walter "Dabba" Jefferson lived just outside the loading dock at Boone Hall Plantation in the late 19th and early 20th centuries. Their first child, Viola, was born in the first brick cabin on the historic avenue of the oaks. The couple hosted many prayer meetings in their home, and on various occasions, Walter invited traveling evangelists to conduct outdoor services for the residents of the plantation. These outdoor services were usually held during the harvest season. At Christmastime, the Jenkins Orphanage Band entertained the families on the dock. (Courtesy of private family collection.)

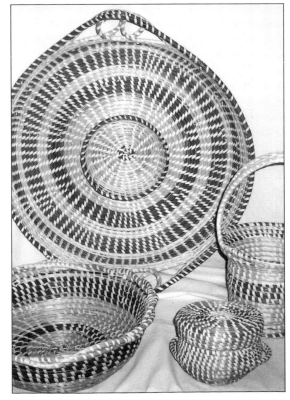

HOPE CHEST. These styles were displayed on the early-1930s basket stands along Highway 17.

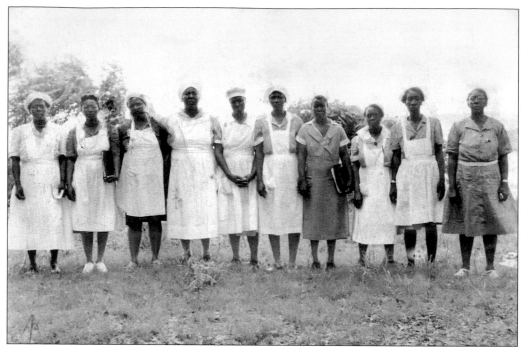

THE GIFT OF LIFE. Penda Green, Alice Smalls, Bella Smalls, and Hessie Huger were midwives who learned the trade from their ancestors but who were later required to take professional training at Voorhees College in Denmark, South Carolina. In 1932, the fee was $5; in 1953, it was $20. (Courtesy of private family collection.)

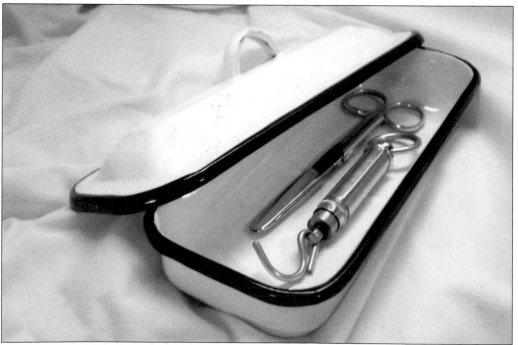

HESSIE HUGER'S TOOLS. These basic medical tools were used by midwives: the scissors were to cut the umbilical cord, and the scale was to weight the newborn.

SWING LOW, SWEET NICKELS AND DIMES. "Trouble, trouble; Trouble all about my soul. But as soon as my feet strikes Zion, I won't be troubled no more," was sung for countless tourists at Boone Hall Plantation, where Bobby Jefferson, shown here with his older sister Viola, lived as youngster in the early 1930s. One lady requested that he sing the song so often that they nicknamed her "Swing Low, Sweet Chariot." She threw coins on the ground after each performance. (Courtesy of private family collection.)

THE ESCAPE HATCH. For over 70 years, one of the most loved and popular men among both children and adults was a man known as "Mr. Scape." He was so named because when he was younger, his family thought that he was dead from a sudden illness. At his funeral, there came a tapping from within the box with a feeble voice saying, "Let me out." From then on, he was known as the man who "escaped" death. This basket design is called the "Escape Hatch" because it resembles a tomb.

CLOSING FUN. The local schools closed their doors just before Memorial Day, each with carefully planned activities. One of the community's favorites was the recitation contest of the 1920s and 1930s. Harry Palmer (born 1930), when he was in third grade, recited "Little fluffy chicken; little woolly lambs; big brown cows and horses, trotting geese and hens. Running through, the clover, sliding down the haystack. Oh! To Grand Pa's farm I'm going the minute school is over." (Courtesy of private family collection.)

A Driver and a Giver. Thomas Bennett was a private chauffeur to J. C. Long, one of Charleston's most celebrated businessmen. Being exposed to numerous transactions and many acts of philanthropy, Thomas was inspired to open a business of his own in the Cook's Field section of Hamlin Beach. Most would agree that he was a generous donor of treats to the children. (Courtesy of private family collection.)

Women in Business. The first female-owned restaurant in the sweetgrass community was established in the late 1930s by Betsy Johnson with Janie Simmons as the head cook. People from throughout the Mount Pleasant area came for famous fresh fish sandwiches. Attached to shop was also a basket stand that drew tourists and regulars from Myrtle Beach. (Courtesy of private family collection.)

113

FROM THE MIDNIGHT CAFÉ. Ferdy and Janie Coakley were a cooking team. Their savory recipes were prepared for visiting relatives every Christmas. Her specialty was deep-dish apple pie; he made a sweet-potato pone from a nearly two-centuries-old recipe acquired from his grandmother, who was a cook on the Boone Hall and Hamlin Plantations. (Courtesy of private family collection.)

ALL ABOARD THE FREEDOM WAGON. Fred Mazyck (pictured here), Thomas Bennett, Abraham Edwards, John Foreman, Fred Brown, "Mr. Scape," and many others provided hack service in the community. Thanks to them, those without cars were able to travel to Charleston to work and shop. The trip in the early 1940s cost 10¢; by the late 1950s, it was 25¢. (Courtesy of private family collection.)

BEAUTIFUL PLACES, FAMILY FACES. Henry Jefferson worked with his father, cousins, and friends with Charleston County for 32 years. He witnessed many of the roads transform from dirt to asphalt. (Courtesy of private family collection.)

DRIVE AND GO FORWARD. The McKnight family provided public transportation to schools, the navy yard, the downtown cigar factory, and various other places for more than three decades. Alfred "Fudd" McKnight started the family service when he purchased an International truck. He took two-by-six lumber and made bench seats. A huge canvas was kept available to place over the passengers during bad weather. Even though their vision was obscured, a breeze always managed to penetrate an opening in the back. (Courtesy of private family collection.)

YUM, YUM, SECOND TO NONE. Martha Manigault Coakley (here with her granddaughter Lillie Amanda), champion cook in the Hamlin Beach community, declared her chicken recipe to be the best in the country. It started with a freshly cleaned hen dipped in cool water and cut in pieces. The hen was simmered on a wood-burning stove for several hours in its own juices, onions, and seasoning. (Courtesy of private family collection.)

A JOB WELL DONE. Virginia German has been the community funeral soloist for more than half a century. She and pianist Amy Edwards began providing the service in the 1940s. Because she worked with Margaurite Johnson, co-owner of the funeral home, Virginia was able to attend all funerals in the community. The official song for Christ Church Parish funerals was "Sit Down, Servant." (Courtesy of private family collection.)

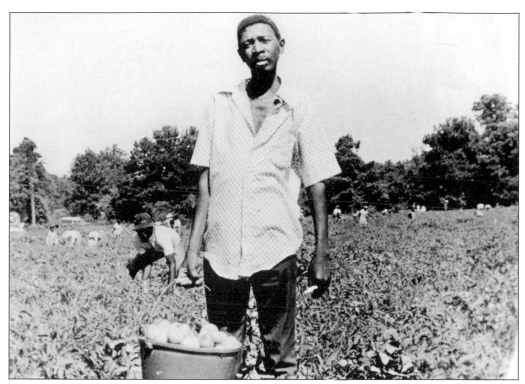

POWER, STRENGTH, AND WISDOM. Fred Moultrie had a heart for the youth of the Hamlin Beach community. As a young child, he witnessed the drowning death of his father. It was this experience that encouraged him to be a community helper. For more than five decades, he provided leadership and skill on the Hamlin Farms. When he was a teenager, he and Laura Conyers were known as the dancing duo of Mount Pleasant, winning many contests as they performed the Charleston and Lindy Hop. (Courtesy of private family collection.)

LEARN NOW, EARN LATER. Rose Bennett Williams (second from left) is shown with her daughter Mary, granddaughter Ruth, and great-grandson Navarro. Rose was an extraordinary businesswoman who sold her vegetables and flowers in Charleston. From these earnings, she was able to secretly save enough to assist Ruth in obtaining a college degree. (Courtesy of private family collection.)

FOURTH OF JULY. The Horlback brothers of Hamlin Beach strike this impressive pose on the annual trip to Atlantic Beach. Cap guns were a favorite in the 1953 era, as youngsters were influenced by westerns that were being broadcast on WCSC, the new television station. (Courtesy of private family collection.)

DIRTY CLOTHES EQUALS CLEAN MONEY. Walter Snype, businessman, inventor, and carpenter, worked as a shipwright for 50 years at the Charleston Naval Shipyard and owned one of the first coin-operated laundromats in Mount Pleasant. Without formal education, he invented an instrument to remove caulking from ships, which saved the shipyard thousands annually. He used the cash award to purchase property. (Courtesy of private family collection.)

UNSUNG HEROES. Alfreda and Isaac German worked as a team to enhance the quality of life in the Mount Pleasant community for more than 50 years. Their organized effort emanated from Goodwill AME Church and included the Joshua Burial Society and many other civic organizations. (Courtesy of private family collection.)

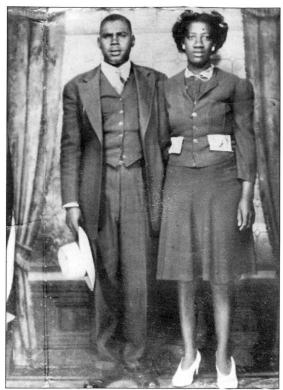

STILL ON BOARD. Mary McConnell spent years delivering telephone messages, receiving telegrams, reading documents, and delivering groceries. At the age of 93 in 2005, she continues to operate the family grocery store. (Courtesy of private family collection.)

CANDY FOR ALL. Freddie Swinton was a barber, church leader, and owner of the local candy store. The children adored him because he extended credit to those who did not have money to buy treats. (Courtesy of private family collection.)

LAW AND ORDER. Judge Dennis Aulds represented the justice system in the sweetgrass community. Open-air trials were held at A. B. McConnell's store from the back of a pick-up truck. He settled cases involving civil suits, traffic violations, and other misdemeanors. Those found guilty invariably received the same punishment: $10 or 10 days. Those unable to pay the fine were taken to the county jail in Charleston. (Courtesy of private family collection.)

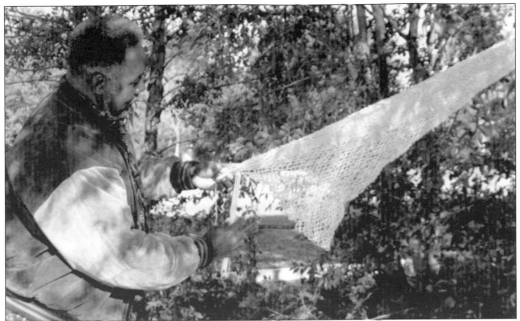

LIFE ON THE WATER. Freddie Coakley Jr., a retired longshoreman from International Longshoremen's Association Local 1422, was taught the skill of net making at an early age and has maintained the family tradition for more than 50 years. He sold his nets to family members and other interested buyers. His granduncle Sam Coakley made nets and built sailboats. (Courtesy of private family collection.)

HOOK, LINE, AND CAPTURE. Lee Palmer was a distinguished dresser from the historic Philip community. When he was retired from the Charleston Naval Shipyard and local mills, he pursued the craft of net making. Most of his days were spent farming and on the river catching fish and shrimp for family members. Lee had the unique characteristic of having six fingers on each hand. (Courtesy of private family collection.)

BOUND FOR GLORY. Margaret and Frank Jefferson, parents of 11 children, were founding members of the Garden of Prayer Church. Frank was one of two deacons first ordained in the early 1960s. It was his responsibility to provide transportation to those who lived too far to walk to church, a task that required up to three trips after midnight on Sunday, Tuesday, and Friday nights. (Courtesy of private family collection.)

LEADER TO MANY. Elizabeth Wilson was one of the first to be ordained a "mother" of the Garden of Prayer Church. She was a Charleston flower lady who sold with her daughters, Rebecca, Celestine, Sarah, and Charlotte. (Courtesy of private family collection.)

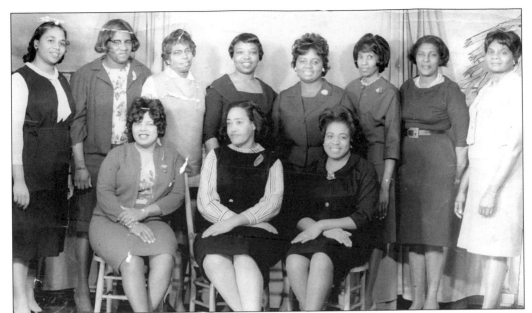

THE WILL TO BELONG. The Federated Women's Club of Mount Pleasant was founded in the Snowden community with the mission of improving conditions in the area by getting the women actively involved in the planning process. They have co-sponsored the annual parade and many other charitable events. (Courtesy of private family collection.)

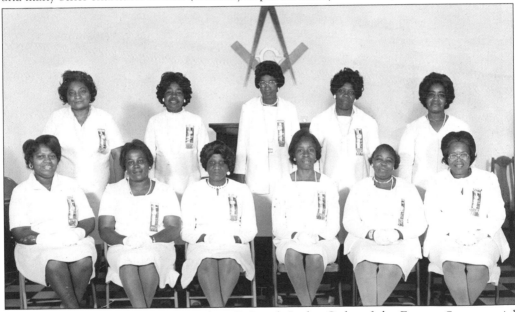

THOSE WHO LEAD MUST SHINE. The 169 Pisgah Lodge Order of the Eastern Star, a social order comprised of women of high spiritual value and character, has attracted members for more than half a century. They possess a deep sisterly bond and pledge to do charitable work in the community and help each other. Virginia C. Robinson, who once taught in a one-room schoolhouse, was a founding member of 169 Pisgah Lodge, was awarded a lifelong certificate for her contributions, and has since been recognized by the state organization of the Order of the Eastern Star for her years of service. (Courtesy of private family collection.)

"Mount Pleasant Dah at 94 Still Minds Her 'Baby,' Now 81" (*The News and Courier*, 1987). Georgie Coakley (far right), born July 1893, began babysitting Edith Guilds in 1906, shortly after her birth. The service was interrupted for a few years while Georgie lived in Florida. The circumstances surrounding the relocation remain a mystery; Georgie would only say, "They stole me away dressed as an old woman. They put a large veil on my head and I rode the train to Florida." Decades later, she returned to Mount Pleasant and resumed her old job as dah to Edith, who was now married. She retained her job until she reached her centenary birthday. She died at 102. (Courtesy of private family collection.)

Dinner for the Dead. Emma "Annie Mum" Conyers kept alive the African burial traditions of her ancestors. In her family, it was customary for the family of the deceased to remain awake on the night of the person's death. Any meal or beverage served was also prepared for the dead. The food was placed on the roof or thrown out of the back door. (Courtesy of private family collection.)

LAST HOME DELIVERY. In the 1960s, Bella Smalls was one of the last practicing midwives in the Mount Pleasant. New certification requirements, access to health-care programs, and legal issues bought to a close the tradition of home delivery. She continued to work at the Boone Hall Plantation gardens and remained active in the burial society. (Courtesy of private family collection.)

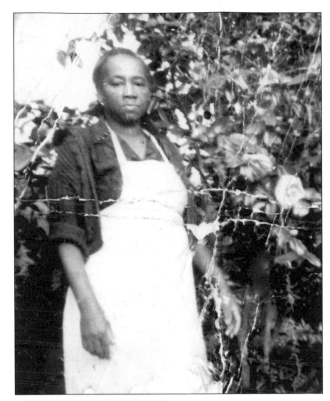

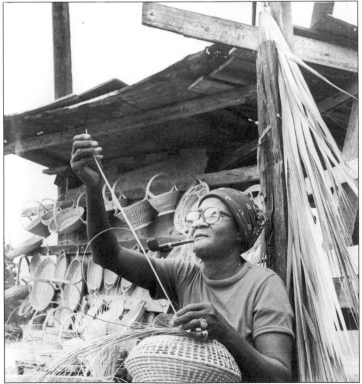

ANOTHER DAY'S JOURNEY. Beatrice Coakley made sweetgrass baskets at her stand for more than 50 years. Her delight was in creating new styles. Though there were weeks when she did not make a single sale, she said that life was just "another day's journey and we must make the best of it." (Courtesy of private family collection.)

THE END OF THE GREATEST. John Bennett was the last to provide door-to-door sale of fresh fruits, vegetables, and peanuts from his horse-drawn wagon. The service was provided throughout the Hamlin and Seven Mile communities until the 1960s, when he retired to his first love, sweetgrass basket making. (Courtesy of private family collection.)

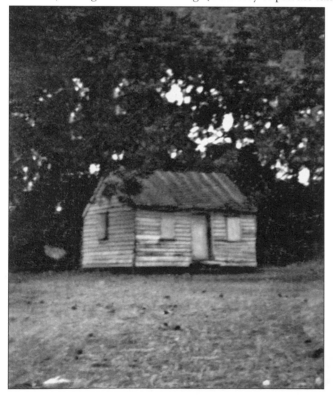

THE LAST SHOUT. One of the last of the remaining praise houses constructed by freed Africans in Christ Church Parish was destroyed by Hurricane Hugo in 1989. Throughout its century of use, it served as a classroom, society hall, and meetinghouse. (Courtesy of private family collection.)

MISSION ACCOMPLISHED. Dolly Coakley Heyward, a pioneer Charleston flower lady, taught her children and grandchild the skill of selling vegetables and flowers in the Charleston City Market and on the streets. She was most remembered for her fearless pursuit of a sale. Each night, she closed her day with the singing of the praise song "John was a Writer." The concluding verse of that song said, "Oh John, fold up your paper; seal up your book; John, don't you write no more." (Courtesy of private family collection.)

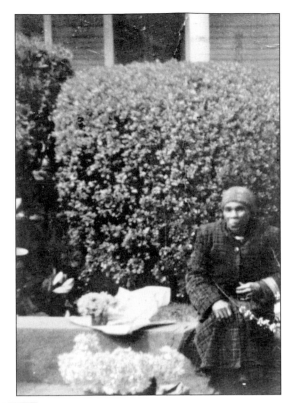

POINT OF NO RETURN. More than three centuries ago, 10 million enslaved men, women, and children left the "Point of No Return" in West Africa during the Atlantic slave trade. Many of them would find home in what is now Mount Pleasant. They were among those who established the Gullah traditions and maintained the art of sweetgrass basket making. (Courtesy of private family collection.)

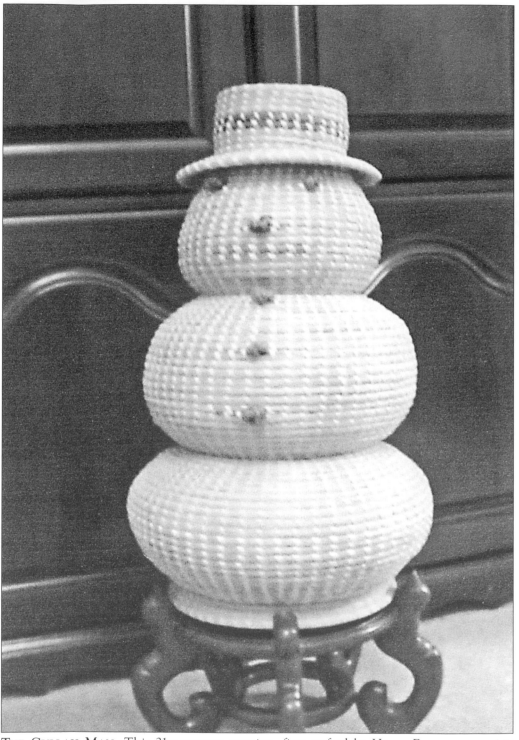

THE GULLAH MAN. This 21st-century creation, first crafted by Henry Foreman, consists of four separate pieces that can be used individually or collectively. (Courtesy of private family collection.)